IMAGES
of America

THE SUFFOLK
PEANUT FESTIVAL

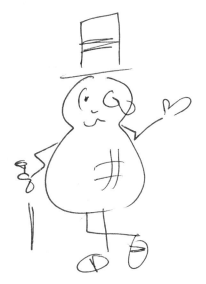

Enjoy & so
nuts!

Patrick
Smithum

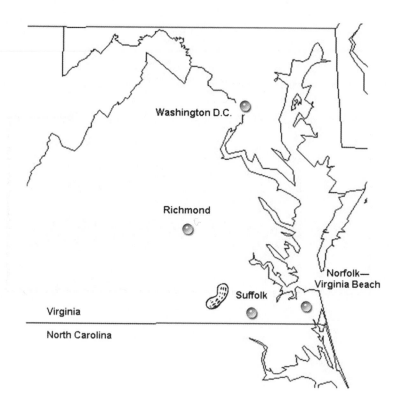

Washington D.C.

Richmond

Norfolk—
Virginia Beach

Suffolk

Virginia

North Carolina

THIS IS PEANUT COUNTRY. Because of soil and climate requirements, there is a limited area in southeastern Virginia where peanuts thrive as a viable cash crop. The Virginia Peanut Belt includes an area south and east of Richmond, to just west of Norfolk and Virginia Beach, an area known as Hampton Roads or Tidewater. In the center of this belt is the city of Suffolk. (PEH.)

IMAGES
of America

THE SUFFOLK PEANUT FESTIVAL

Patrick Evans-Hylton

ARCADIA

Published by Arcadia Publishing
Charleston SC, Chicago, Portsmouth NH, San Francisco

Printed in Great Britain

Library of Congress Catalog Card Number: 2004102684

For all general information contact Arcadia Publishing at:
Telephone 843-853-2070
Fax 843-853-0044
E-mail sales@arcadiapublishing.com
For customer service and orders:
Toll-Free 1-888-313-2665

Visit us on the internet at http://www.arcadiapublishing.com

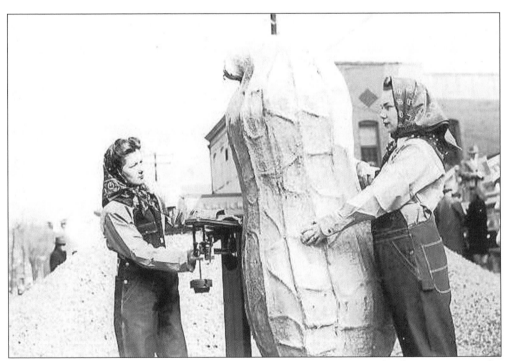

THAT'S ONE GIGANTIC GOOBER. These peanut plant workers pose with a huge papier-mâche peanut during the parade at the first National Peanut Festival in January 1941 in Suffolk. The fete included a parade, dances, beauty queens, and more in recognition of the town as the world's largest peanut market. Peanuts have been big business in Suffolk since the late 1800s. (SPF.)

CONTENTS

ACKNOWLEDGMENTS

Compiling information and photographs that chronicle the history of the little peanut and the festival that celebrates it was no small task. It was only possible due to the assistance and expertise of many giving and gifted individuals. For everyone who lent their time, talent, and support in this effort, I thank you.

I would like to personally thank the following individuals who went above and beyond in their assistance and support: Susan Beck and Katie White of Arcadia Publishing; H. Tyrone Brandyburg of the Tuskegee Institute National Historic Site; Lynette Brugeman, tourism director for the city of Suffolk; Cheryl Cromer of the Suffolk Master Gardeners Association; Jolyne Dalzell, grand-niece of Planters Peanuts founder Amedeo Obici, and her husband, Dan Dalzell; Edwin Goodrich, president of Plantation Peanuts; Pam Lowney of Obici Hospital; Dale Neighbors, executive director of the Murfreesboro Historical Association; Tommy O'Connor, peanut collector extraordinaire; Betsy Owens, executive director of Virginia-North Carolina Peanut Promotions; James Pond and his staff at Producers Peanut Company; Robin Rountree, Lee King, Sara Ann Johnson, and the board of directors at Riddick's Folly House Museum; and Linda Stevens, Lisa Key, and the board of directors of Suffolk Peanut Festival/Suffolk Festivals, Inc. Thank you, also, to folks at the National Peanut Board, Virginia Tech, and the Colonial Williamsburg Foundation.

A special thanks for moral support and encouragement is due to my friends at *Hampton Roads Magazine*, including my editor Bonn Garrett, and editorial assistant Lynsey Ring; and my friends Victoria Hecht, Stephen Cowles, Chad Martin, Steve and Marisa Marsey, Tammy Jaxtheimer, Mark Hall, Joyce Williams, and my family, especially Wayne.

INTRODUCTION

Today, the peanut isn't given much thought. It's eaten at parties and baseball games. Peanut butter is spread on crackers and bread for a quick snack or meal. But that's about it. That wasn't the case almost 5,000 years ago, when ancient Peruvians buried pots of goobers with their dead to feed them on their journey to the next life. Spanish and Portuguese explorers took plants with them to Africa and the Far East.

Peanuts took root in the tropical climate of Africa and became an important part of the diet. The Bantu called them "nguba," the origin of our word "goober." Other names for the peanut/goober are goober pea, groundnut, pindar, earthnut, peendar, Manila nut, and monkey nut. Although white men did eat peanuts, it wasn't done on a wide-scale basis. Until the 1850s, peanuts were mostly food for slaves, the poor, and animals.

German physician Johann David Schoeph traveled through Virginia and the South in 1783 and 1784, and he states in his journal, "Besides what the negroes raise for their own use, planters here and there in the southern colonies cultivate great quantities of them to fatten their hogs and fowls, which gain rapidly on such feed." Thomas Jefferson was known to have grown a small patch of peanuts; he noted in 1794 that about one-and-one-half peck was cultivated.

The first commercial peanut crop was grown in Virginia in 1842 by Dr. Matthew Harris near Waverly. He sold his crop on court day in Petersburg and Jerusalem, now Courtland. A recipe for "groundnut cakes" appeared in *The Carolina Housewife*, penned by Sarah Rutledge in 1847, showing that peanuts were becoming more mainstream by then. The recipe reads, "Blanch one pound of groundnuts; beat them very fine in a marble mortar, adding a little brandy while pounding to prevent oiling. Then add ten eggs, one pound of sugar, and one pound of butter. Beat the whole well together; make a puff paste, lay it on your tins, and fill them with the mixture; grate lump sugar over them, and bake in a slow oven." During the Civil War Confederate soldiers sometimes had nothing to eat except for peanuts. They found them to be easily portable and high in protein. Union soldiers passing though the South also tried peanuts—or goober peas—and found them to their liking.

The planting, digging, stacking, picking, cleaning, and drying is a laborious task that wasn't made easy until mechanization in the mid- to late 1800s. In addition to technological advancements in peanut cultivation, new uses for the goobers also increased their popularity. In the 1890s George Washington Carver, of Alabama's Tuskegee Institute, began touting the peanut as a replacement crop for cotton, which had been all but destroyed by the boll weevil.

As an inducement he developed hundreds of uses for peanuts, from snacks to meals to industrial products. About the same time, peanuts became a favored nibble at circuses, baseball games, and other events. Vendors sold them from carts pushed down the street. Folks soon picked them as a favorite snack food.

Because the peanut requires a subtropical or tropical climate, the American South grew the bulk of the country's supply. Suffolk and Nansemond County lie in the heart of the Peanut Belt. The March 1902 Illustrated Industrial Edition of the *Suffolk Herald* reported, "In Isle of Wight, Nansemond and Surry counties alone there are not less than ten factories devoted to the cleaning, sorting, grading and bleaching of peanuts. These factories employ fully nine hundred hands, including a great many women, and as a rule are operated without intermission the year through." Because of the output of the four factories located in Suffolk alone, the newspaper called the town "the largest peanut market in the world." Perhaps the best-known peanut factory relocated to Suffolk from Wilkes-Barre, Pennsylvania, in 1913. In order to be closer to the farmers that supplied his peanuts, Amedeo Obici and his business partner Mario Peruzzi moved their business, Planters Nut and Chocolate Company, to town. Mr. Peanut was born in 1916, when 14-year-old Anthony Gentile won a drawing contest sponsored by Planters. Obici wanted the peanut person to be more "aristocratic," so a graphic artist added a top hat, monocle, cane and spats.

Over the next several decades the peanut industry continued to grow. By 1940 the *Suffolk News-Herald* reported it to be a $25 million business in Virginia. The next year, the town decided to throw a party in the goober's honor. A newspaper article reported, "Plans have been completed here for the staging on January 28 and 29 of the National Peanut Festival, to be held during National Peanut Week from January 23 to 31 . . . The celebration will include an elaborate parade several miles long, a nationally famous dance band, a movie star celebrity queen and other features including many distinguished guests. Plans are now being completed for the various events which will bring the largest crowd in history to Suffolk for the two-day celebration." The crowd was estimated to be 10,000, a number that grew to 50,000 by the second Peanut Fest in October 1941. Today's four-day Peanut Fest, held each October at the Suffolk Municipal Airport, draws more than 200,000. Not bad numbers for the lowly peanut.

PHOTOGRAPH LEGEND:

JD: From the personal collection of Jolyne Dalzell.
RFM: From the archives of Riddick's Folly Museum, Suffolk.
SMG: From the archives of the Suffolk Master Gardener Association.
SPF: From the archives of Suffolk Festivals Inc. and the Suffolk Peanut Festival.
TO: From the personal collection of Tommy O'Connor.
PEH: From the personal collection of Patrick Evans-Hylton.
All other photographs are individually credited.

One

HISTORY OF THE PEANUT

The peanut made its way to Africa a half-millenia ago and with the slave trade found its way to North America. Little more than 150 years ago, the peanut was mostly feed for the poor or livestock. With other food scarce, it became recognized as a cheap form of protein and an important food source during the Civil War. Union soldiers passing through Virginia fields took the nuts home with them. By the late 1800s peanut venders were selling hot roasted nuts on street corners, at circuses, and in baseball parks, and Virginia supplied most of the northeastern market with peanuts. George Washington Carver discovered many new uses, from peanut flour to peanut pastry. Thanks to new technology for planting, harvesting, and production, the peanut became an important cash crop.

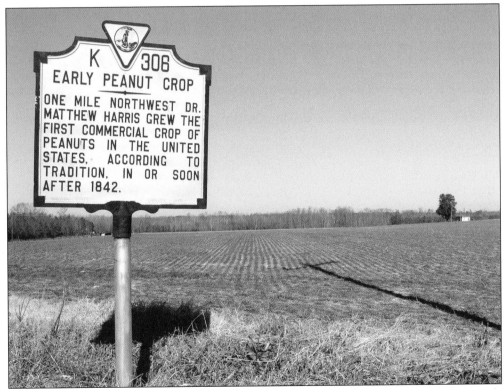

EARLY PEANUT CROP. This roadside marker on Route 460 between Suffolk and Waverly commemorates the first known commercial crop of peanuts planted in the United States. Tradition says Dr. Matthew Harris, after receiving peanuts as a gift, selected the best, planted them, and sold the bushels to a peddler who retailed them in the area and generated interest in the legume as a foodstuff. (PEH.)

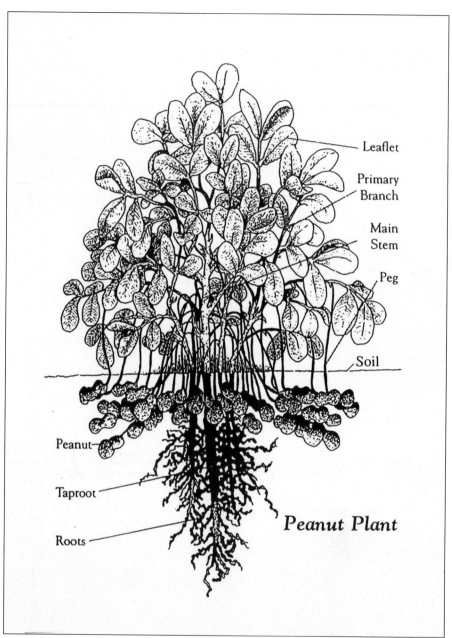

Leaflet

Primary
Branch

Main
Stem

Peg

Soil

Peanut

Taproot

Roots

Peanut Plant

A Peanut Plant. The peanut is not a true nut but rather a legume. It is unusual because it flowers above the ground but fruits below the ground. It does not grow on trees, like walnuts or pecans, and is not part of the growing root, like potatoes. Peanuts are planted about two inches deep, one every three or four inches, in rows about three feet apart. Peanuts grow best in sandy soil rich in calcium. Green, oval-shaped leaves form, and the plant grows to about 18 inches tall. Yellow flowers pollinate themselves, lose their petals, and drop to the ground. The "peg" extends into the soil, matures, and develops into a peanut. A typical plant produces some 40 or more mature pods. Depending on the variety 120 to 160 frost-free days are required for a good crop. Peanuts primarily grown in Virginia are the Virginia type, a large legume referred to as "the peanut of gourmets." (Courtesy of Virginia-Carolina Peanut Promotions.)

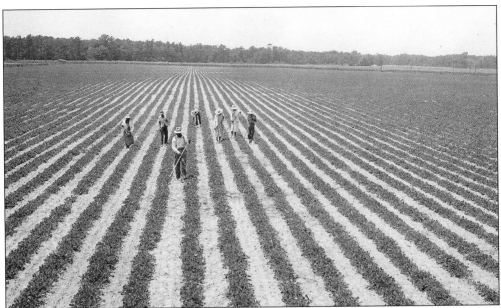

CULTIVATING A PEANUT FIELD WITH A HOE. Peanut seeds are planted in rows about three feet apart. If the soil temperature is warm, between 65 and 70 degrees, and given enough water, the seeds will sprout. A good crop develops in 120 to 160 days. In this early 20th-century photograph, the laborious task of cultivating the fields is done without the aid of machinery. (SMG.)

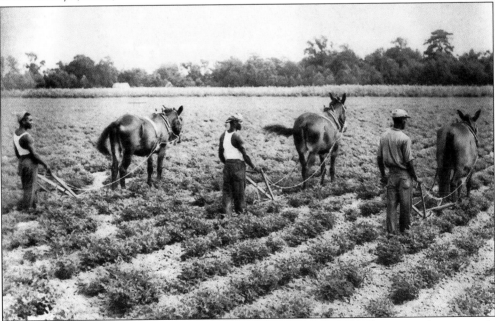

CULTIVATING A PEANUT FIELD WITH A MULE AND PLOW. Peanut plants grow best in sandy soil rich in calcium. Because of temperature requirements, the plant is best cultivated in Southern states. Virginia is the northernmost state where the legume thrives. In this early 20th-century photograph, the backbreaking job of cultivating the field is aided with mule and plow. Development of mechanized cultivation helped the peanut industry grow. (SMG.)

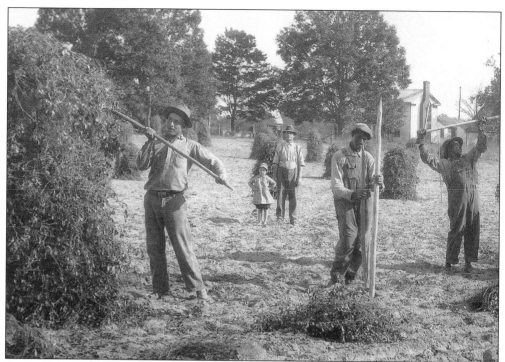

DUG PEANUT VINES ARE STACKED ON POLES TO DRY. When the peanut plant has matured and the peanuts are ready to be harvested, the farmer digs up the plant, and it is allowed to dry before the legume is separated from the vines. Here, workers stack the vines on pointed poles to dry, a method widely used until the early 1960s. (SMG.)

A FARMER INSPECTS HIS CROP. Until the mid-20th century, peanut plants were stacked on pointed poles to allow for drying before separating the nut from the vine. When dug, peanuts contain up to 50 percent moisture and must be dried to 10 percent or less so they can be stored without spoiling. Traditionally peanuts are left to dry for two or more days in the field before being threshed. (SMG.)

FIELD OF PEANUT VINES DRYING ON POLES. This early 20th century photo also shows the traditional method of stacking, or shocking, peanuts to dry before threshing. The windrow method is typically used now; a dug plant is laid peanut-side-up, leaf-side-down in a row for drying. Then the farmer drives his combine over the windrows, and the machine separates the peanuts from the vine. (SMG.)

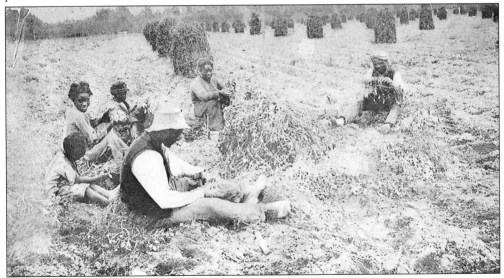

HARVESTING PEANUTS IN VIRGINIA. This postcard, published by G.E. Murrell of Lynchburg, Virginia, shows the time-consuming task of separating peanuts from the vine by hand. It wasn't until the process was mechanized that peanuts became a truly viable cash crop. In the fall and winter, pickers, paid $10 monthly, would start before daybreak and work into the night by the light of lanterns. (TO.)

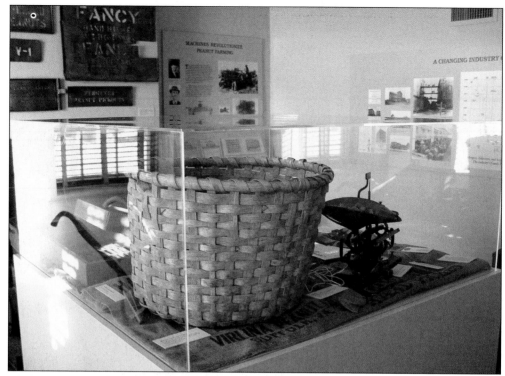

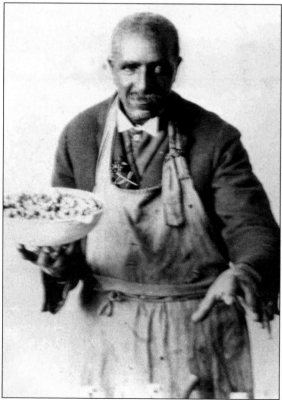

AN EARLY PEANUT-PICKING BASKET. This basket, used in the early 1900s to gather peanuts, is on display in the Peanut Museum at Riddick's Folly Museum in Suffolk. Stacks, or shocks, of peanuts would have been moved to a central field location and placed in a circle to break the fall and winter winds for the pickers inside, who worked all day and into the night. (PEH.)

A PEANUT PIONEER. George Washington Carver, the son of slaves, was born in Missouri in 1864. He broke racial barriers by attending agricultural college in Iowa where he earned bachelor's and master's degrees in science. In 1897 he began teaching at the Tuskegee Normal and Industrial Institute for Negroes and began work on uses for many crops, including soybeans, sweet potatoes, and peanuts. (Courtesy of the George Washington Carver Museum.)

14

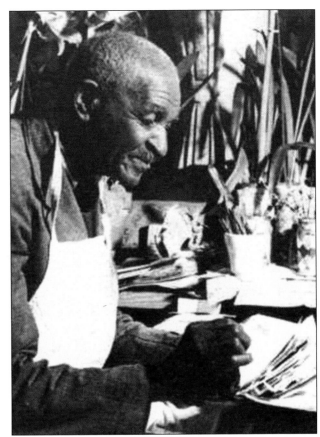

GEORGE WASHINGTON CARVER, PEANUT ADVOCATE. From 1897, work by George Washington Carver was instrumental in development of the peanut as a cash crop. He developed more than 300 uses for the peanut. Carver said he asked the Great Creator, "Dear Mr. Creator, please tell me what the universe was made for." The Great Creator answered, "You want to know too much for that little mind of yours. Ask for something more your size." Then he asked, "Dear Mr. Creator, tell me what man was made for." Again the Great Creator replied, "Little man you still are asking too much. Cut down the extent of your request and improve the intent." So then he asked, " Please Mr. Creator, will you tell me why the peanut was made?" (Courtesy of the George Washington Carver Museum.)

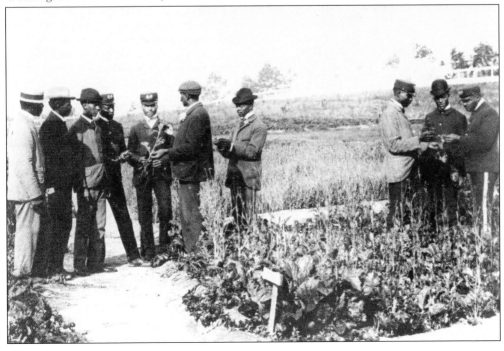

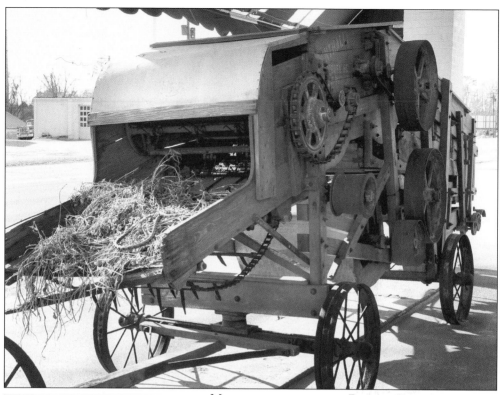

MECHANIZATION OF THE PEANUT BEGINS.
Inventor Jesse Thomas Benthall was born in Hertford County, North Carolina, in 1856. His mechanized peanut-picking machine was instrumental in developing the peanut as a viable cash crop. Benthall partnered with Finton Ferguson and moved to Suffolk in 1906 to start Benthall Machine Company. This photograph shows an early Benthall machine on display at Plantation Peanuts gift shop in Wakefield, Virginia. (PEH.)

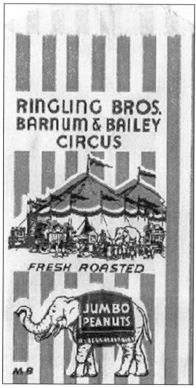

THE GREATEST SNACK ON EARTH. Phineas Taylor Barnum was born in 1810 and became one of the world's most famous showmen. He began his Grand Traveling Circus in 1870. Since the mid-1800s, folks snacked on peanuts at circuses; they did at Barnum's show, too. When P.T. Barnum introduced Jumbo the Elephant in 1882, the bond between pachyderm and peanut was forever forged. This vintage bag memorializes Jumbo. (PEH.)

16

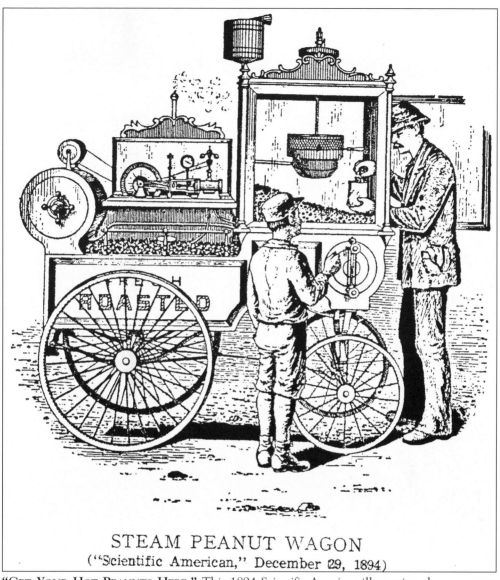

STEAM PEANUT WAGON
("Scientific American," December 29, 1894)

"GET YOUR HOT PEANUTS HERE." This 1894 *Scientific American* illustration shows a street vendor selling his goods to a young boy. A peddler selling 30 bushels at Petersburg and Jerusalem (now Courtland), Virginia, on court day in 1842 inspired Matthew Harris, planter of the first commercial peanut crop in the United States, to continue with his commercial enterprise. By the mid-1800s they were sold by vendors in theaters and were popular among the working class—thus the term "peanut gallery." Peddlers at circuses and on street corners also sold them. They were aided by the invention of the mobile peanut wagon in 1885, which could roast the nuts while a steam condenser kept the peanuts warm. Perhaps the most famous peanut vendor was Amedeo Obici, who bought a roaster in 1896 and sold them from a horse-drawn cart in Wilkes-Barre, Pennsylvania. Obici would later found Planters Peanuts. (TO.)

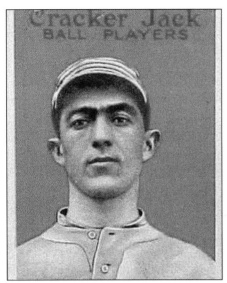 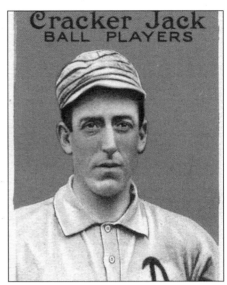

"THAT'S A CRACKER JACK!" Peanuts were already a popular snack in 1893, when brothers F.W. and Louis Rueckheim combined them with popcorn and molasses. Tradition says a salesman who tried the confection exclaimed "That's a Cracker Jack!" and the name stuck. Nuts were popular at sporting events, as memorialized in Jack Norworth's 1908 song "Take Me Out to the Ball Game," which includes the line "Buy me some peanuts and Cracker Jack." Baseball cards, like the vintage pair shown here, were prizes in Cracker Jack boxes in 1915. (PEH.)

THE FIRST PEANUT MUSEUM IN THE UNITED STATES. As an homage to the goober this Peanut Museum opened in a renovated shed behind the Miles B. Carpenter Museum in Waverly, Virginia, in 1990. The museum is just a few miles from where tradition says the first commercial crop of peanuts was planted by Matthew Harris in 1842. Memorabilia, information, and farm equipment are on display. (PEH.)

Two

SUFFOLK AT THE TURN OF THE 20TH CENTURY

The first mill for cleaning, grading, and shelling peanuts in Suffolk was opened by Farmers Alliance of Nansemond County in 1890, and Suffolk Peanut Company started operation in 1897. The March 1902 Illustrated Industrial Edition of the Suffolk Herald reported, "The inference that Suffolk would be a splendid manufacturing site is sustained by facts. There are now numerous factories here, all of which are prosperous. Among them we may mention four large peanut factories, employing several hundred hands and preparing and shipping enormous quantities of peanuts each day, making Suffolk the largest peanut market in the world." In 1913 Italian immigrant Amedeo Obici moved Planter's Nut and Chocolate Company to Suffolk. Suffolk first celebrated peanuts in the mid-20th century with the National Peanut Festival and later with Harvest Festival. The goober still remains an important crop.

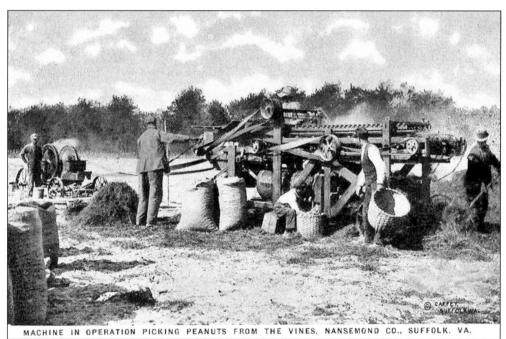

MACHINE IN OPERATION PICKING PEANUTS FROM THE VINES. NANSEMOND CO., SUFFOLK, VA.

MACHINE IN OPERATION PICKING PEANUTS FROM THE VINES. This early 20th-century postcard shows laborers in Nansemond County, today the city of Suffolk. Use of mechanized methods increased along with demand. The first notable increase in American peanut consumption came in the early 1860s at the outbreak of the Civil War. Peanuts were an easy source of protein and met with soldiers' liking. (TO.)

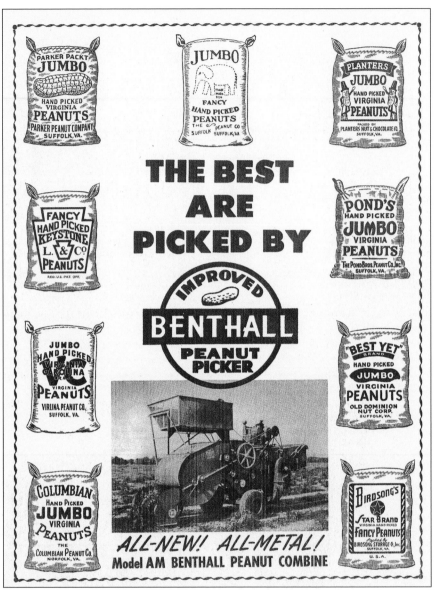

THE PEANUT IS KING. By the mid-1900s the peanut was the predominate cash crop in Suffolk and in neighboring counties like Southampton, Isle of Wight, Sussex, Greensville, Surry, Dinwiddie, and Prince George. This advertisement, which appeared in the 1958 Suffolk-Nansemond Festival program, illustrates some of the largest peanut producers in the region, while boasting the advantages of mechanical peanut pickers manufactured by Benthall. Around 1900, laborsaving equipment was invented for planting, cultivating, harvesting, picking, shelling, and cleaning peanuts. With these machines, peanuts rapidly came into demand for eating out of hand, peanut butter, and oil. Jesse T. Benthall of North Carolina was a pioneer in this field. He moved his operations to Suffolk in 1906, and his company survived until the 1960s. Dried peanut vines are fed into one end of the picker and are thrashed to separate the nuts from the vines and leaves, which are blown out the other end. Nuts come from an opening and fill baskets and burlap bags. Machines were first mule-powered and later powered by tractors or gasoline. (Courtesy of the City of Suffolk Department of Tourism.)

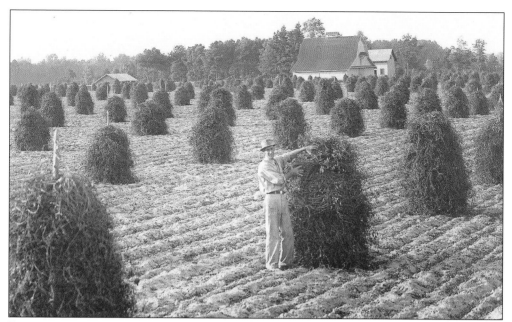

FIELD OF PEANUT VINES DRYING ON POLES. The stacking, or shocking method of drying peanuts until the nuts could be separated from the vine was used until the 1960s. The sight of these stacks was a familiar scene each autumn. Until picking could be mechanized it was done by hand; sometimes picking parties were held with peanut roastings and singing around the shocks while the labor was done. (SMG.)

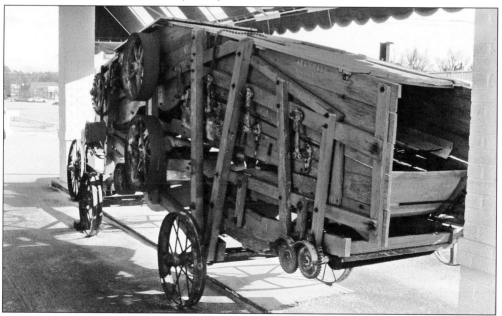

AN EARLY BENTHALL PEANUT PICKER. This early-model Benthall peanut picker was manufactured by the Benthall Machine Company in Suffolk and is currently on display in front of the Plantation Peanuts gift shop in Wakefield, Virginia. The earliest mention of mechanized peanut picking was by Wilmington, North Carolina farmer Nicholas N. Nixon in 1868, although they were not widely available or utilized until about 1900. (PEH.)

THE GOODRICH PEANUT DIGGER. C.L. Goodrich invented this piece of farm equipment in the early 20th century. Attached to either a mule or tractor, it dug up peanuts and shook them free of excess dirt. Manufacturers saved up to two-thirds of their labor costs with this machine. This model is on display at Plantation Peanuts in Wakefield by the inventor's grandson, Edwin Goodrich. (PEH.)

PEANUTS CAN BE SEEN CLINGING TO VINES. In this early 20th-century photograph workers behind a tractor use a peanut digger to hoist peanuts onto pointed stakes in the stacking or shocking method for drying. The first patent for a picker was issued in Surry County, Virginia, in 1868 to J.C. Underwood who called his invention an "Improved Pea-Nut Machine for Picking and Cleaning Peanuts." (SMG.)

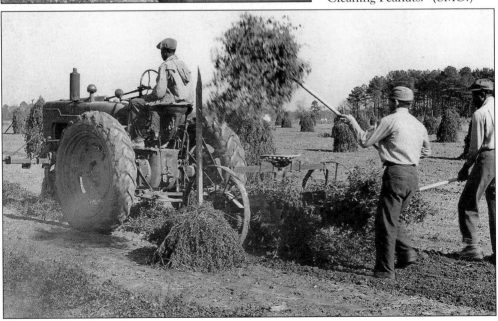

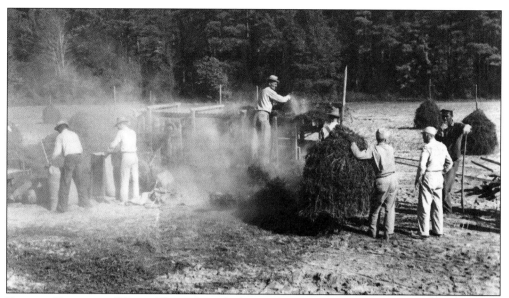

PEANUT PICKER AT WORK. The extremely dusty job of using a peanut picker is evident in this early 20th-century photograph showing laborers feeding peanuts on the vine into the machine. Vines are expelled from the other end, and peanuts are caught in baskets and transferred to burlap bags, which are sewn shut and put on a truck, as seen on the left. (SMG.)

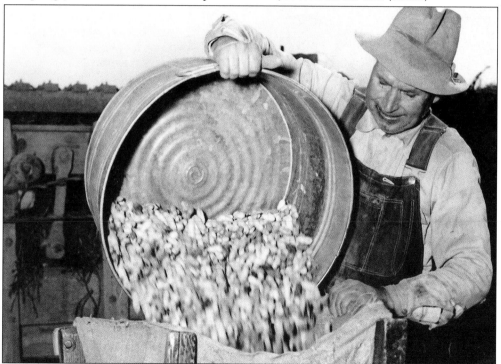

FILLING THE BAGS. Farmer Frank Davis dumps a washtub full of peanuts collected from the picker into a burlap bag. The bag is then sewn closed and loaded onto a trailer for a trip to the market. At the time, there were four peanut grades: fancy, prime, ordinary, and inferior. (SMG.)

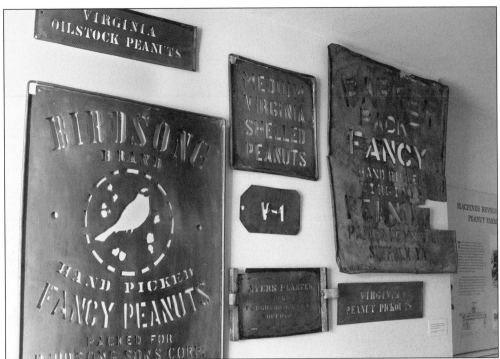

COPPER BAG STENCILS. These shiny copper plates, on display in the Peanut Museum inside Riddick's Folly Museum in Suffolk, served as stencils to imprint company names, logos, and other particulars onto burlap bags before being filled with peanuts. These stencils date from the early to mid-20th century. At the forefront is Birdsong Peanuts, which still operates in Suffolk. Notice the grade of "fancy." (PEH.)

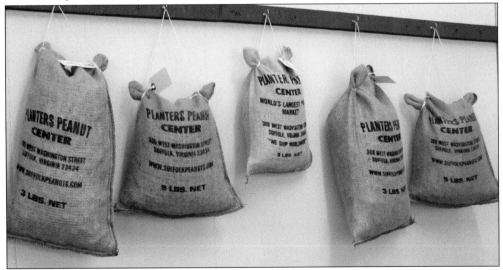

CONTEMPORARY BURLAP BAGS OF PEANUTS. This assortment of burlap bags filled with peanuts is on display and for sale at the Planters Peanut Center in Suffolk. The quaint shop, complete with an authentic, century-old roaster, retails a variety of peanut and other nut products, including the nut-filled burlap bags. In a nod to the 21st century, notice the internet address on the bag. (PEH.)

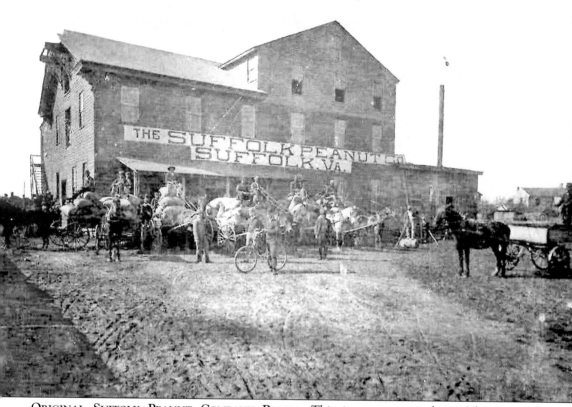

ORIGINAL SUFFOLK PEANUT COMPANY PLANT. This is a very rare, late 19th-century photograph of the Suffolk Peanut Company, the first successful peanut-processing business in Suffolk, established in 1897. The company set up shop in an abandoned cotton mill, which was leased and altered to accommodate the peanut processing machinery. John B. Pinner and John King of Windsor, Virginia, founded the Suffolk Peanut Company, with $10,000 in capital, of which Pinner himself put up $5,000. King later withdrew from the company and was succeeded by A.T. Holland. The small mill expanded, and a third plant was built in 1909. By 1915, the Suffolk Peanut Company employed between 200 and 300 workers and an office staff of 15. Note the horse-and-buggy tracks in the forefront of this picture and lack of automobile tire tracks. (TO.)

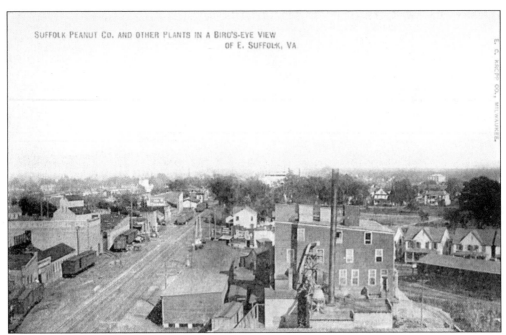

SUFFOLK PEANUT CO. AND OTHER PLANTS IN A BIRD'S-EYE VIEW OF E. SUFFOLK, VA. This early 20th-century postcard shows portions of the Suffolk Peanut Company to the right of the photograph and buildings in the eastern part of the town, just south of downtown. The railroad tracks, bringing in raw product and shipping processed nuts, were the lifeline for the Suffolk Peanut Company and other peanut processors. (TO.)

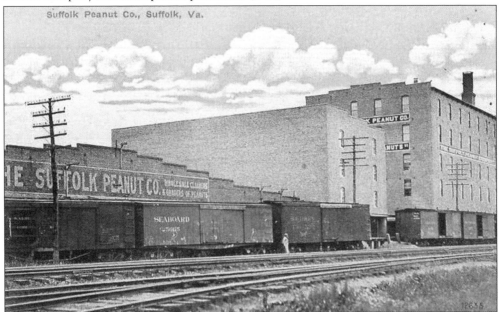

SUFFOLK PEANUT COMPANY FACILITIES. Various warehouses and processing buildings of the Suffolk Peanut Company are shown in this early 20th-century postcard. Facilities grew from the original 1897 cotton mill, and a third plant was built in 1909. The plant was destroyed by fire in 1931 and was rebuilt in 1932. (TO.)

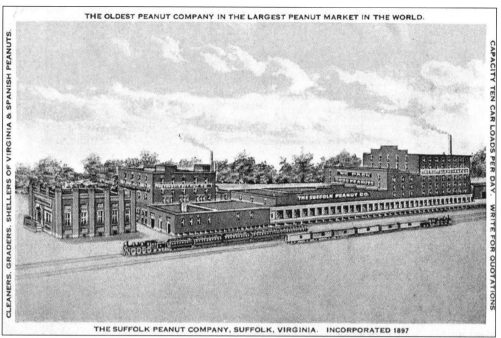

THE OLDEST PEANUT COMPANY IN THE LARGEST PEANUT MARKET IN THE WORLD.

CLEANERS. GRADERS. SHELLERS OF VIRGINIA & SPANISH PEANUTS.

CAPACITY TEN CAR LOADS PER DAY. WRITE FOR QUOTATIONS

THE SUFFOLK PEANUT COMPANY, SUFFOLK, VIRGINIA. INCORPORATED 1897

THE OLDEST PEANUT COMPANY IN THE LARGEST PEANUT MARKET IN THE WORLD. These postcards show the Suffolk Peanut Company facilities. The company, established in 1897, boasted that 10 car loads of peanuts a day could be processed from its sprawling factory when these cards were printed in the early 20th century. The top card says the company cleans, grades, and shells Virginia and Spanish peanuts, two varieties of the legume. Many of these buildings still stand today. One is in use by an electrical contracting company, and the others still process peanuts, now under the Golden Peanut Company banner. (TO.)

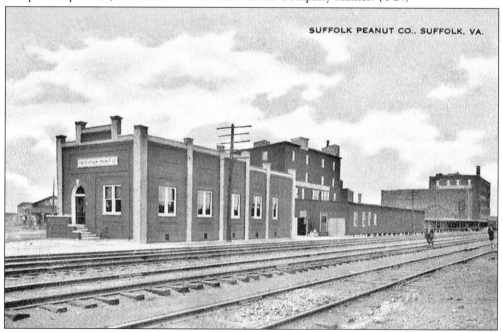

SUFFOLK PEANUT CO., SUFFOLK, VA.

27

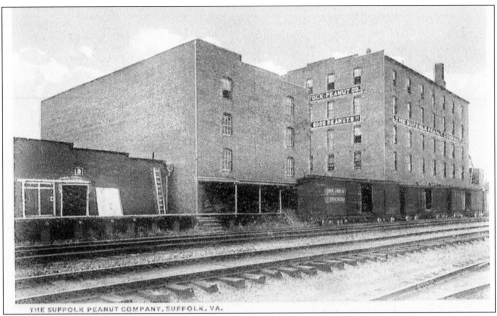

LOADING DOCKS OF THE SUFFOLK PEANUT COMPANY. Southern Railway cars wait at the loading docks. In the early 20th century, Suffolk was the world's largest peanut market. The *Suffolk Herald* boasted in 1902, "There are now numerous factories here, all of which are prosperous. Among them we may mention four large peanut factories, employing several hundred hands and preparing and shipping enormous quantities of peanuts each day." (TO.)

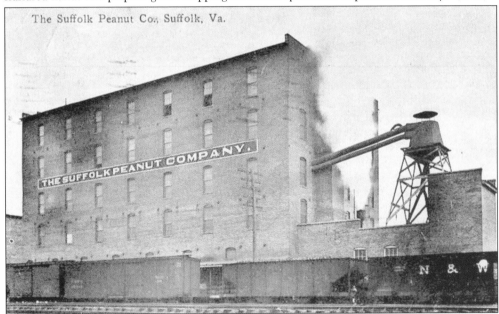

NORFOLK & WESTERN RAILWAY CARS WAIT TO BE FILLED. More railway cars wait at the Suffolk Peanut Company to be filled with processed nuts and shipped to peanut manufacturers. With the Suffolk Peanut Company and other plants like Lummis Peanut Company and Bain Peanut Company running at the turn of the 20th century, the local *Suffolk Herald* called the town "the largest peanut market in the world" in 1902. (TO.)

THE JOHN KING PEANUT COMPANY ADVERTISING POSTCARD. This advertising postcard, postmarked 1911, promotes the John King Peanut Company, cleaners, graders, shellers, and wholesale dealers in Virginia and Spanish peanuts. King, of Windsor, Virginia, had partnered with John Pinner to form Suffolk Peanut Company but withdrew in 1908. His plant, located on Hall Street, employed 150 people in 1915. Planters bought the company in 1926. (TO.)

THE BAIN PEANUT COMPANY, LARGEST PEANUT FACTORY IN THE WORLD. This early 20th-century postcard shows the fireproof five-story Bain plant, employing 20 men and 125 women and storing 20,000 bags of nuts. By 1849 Wakefield, Virginia merchant L. Franklin Bain began selling peanuts at his country store, establishing the Bain Peanut Company in 1890. The firm reorganized as American Peanut Corporation in 1906 and was absorbed by Birdsong Storage in 1914. (TO.)

THE JOHN KING PEANUT CO., Inc.

CLEANERS, GRADERS, SHELLERS
AND WHOLESALE DEALERS IN

VIRGINIA AND SPANISH PEANUTS

NEW PEANUTS!

SUFFOLK, VA., Nov. 17th, 1911.

Please note change in prices of our quotations of Nov. 9.

We quote for prompt and thirty-day shipment, in limited quantities, as follows:

King Jumbos	5¾
Queen of Va., F. H. P.	4¾
Champion Extra, H. P.	3¾
Extra Large Va. Shelled	8
No. 1 Virginia Shelled	5¾
No. 2 Virginia Shelled	4
No. 1 Spanish Shelled	5½
No. 2 Spanish Shelled	4¼

F. O. B. Suffolk, Norfolk rate of freight guaranteed. Thirty days' time, less 1% ten days.
We shall be pleased to serve you.

THE JOHN KING PEANUT CO., Inc.

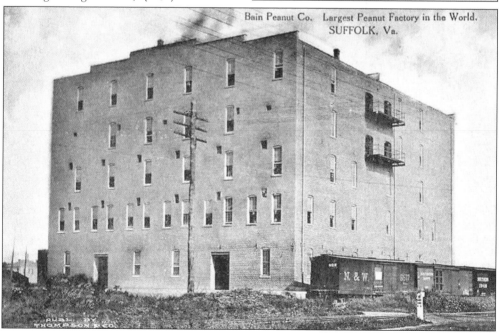

Bain Peanut Co. Largest Peanut Factory in the World.
SUFFOLK, Va.

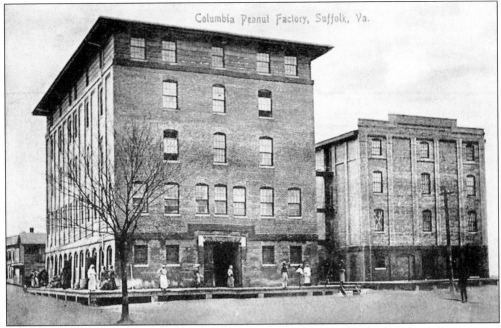

COLUMBIA PEANUT FACTORY. The processing plant of the Columbian Peanut Company is shown in this early 20th-century postcard. John L. Roper of Norfolk started the business, which also had plants in North Carolina and Norfolk (starting in 1892), Smithfield, and Wakefield, Virginia. Roper also started Norfolk Shipbuilding and had lumber interests in North Carolina. (TO.)

THE LUMMIS PEANUT COMPANY BUILDING. This building still stands in East Suffolk, boarded up and waiting for reuse or demolition. The Lummis Peanut Company was organized in 1879 in Philadelphia. This facility was built in 1901 and the *Suffolk Herald* called it "a modern and substantial brick structure" when it opened. Also visible on the building are the signs of former tenants Gold Kist Peanuts and Golden Peanut Company. (PEH.)

LUMMIS PEANUT COMPANY BUILDING, BUILT IN 1901. When this structure opened at the turn of the 20th century, it was one of four large peanut companies in Suffolk. In the surrounding Nansemond, Isle of Wight, and Surry Counties, there were an additional 10 peanut factories; there were only 20 total in America "devoted to the cleaning, sorting, grading and bleaching of peanuts," according to the *Suffolk Herald* in 1902. (PEH.)

POND BROTHERS PEANUT COMPANY PLANT. This East Suffolk plant was home to the Pond Brothers Peanut Company. The business, started by W.T. Pond Sr., C.B. Pond Sr., and L.L. Pond, was established in 1915 by buying the property of the Pope Peanut Company, which had a small plant in Suffolk. The company was sold in 1997. The factory and warehouses are now abandoned. (PEH.)

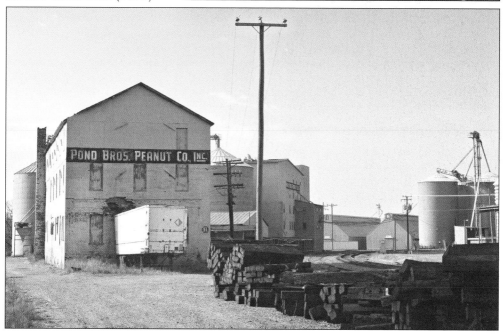

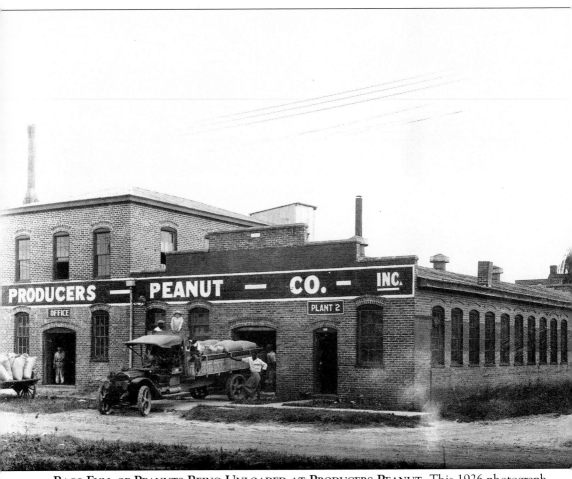

Bags Full of Peanuts Being Unloaded at Producers Peanut. This 1926 photograph shows trucks with bags of peanuts being unloaded at the Producers Peanut Company facility. The company was formed in 1924. A fire destroyed the building seen in this photograph, and Producers Peanut is operating in a new facility with a store that is open to the public. Producers manufactures creamy or chunky style peanut butter, natural peanut butter with and without salt, and products for foodservice and bakeries. The retail unit, Peanut Kids Company Store, sells a variety of products and gift baskets. Only a handful of companies ever produced peanut butter in Suffolk, notably Old Reliable Peanut Company that began in 1912, although many of the processed peanuts eventually wound up elsewhere as the sticky spread. Peanut butter as we know it was created around 1890, and by 1895 it was being served to patients at the Battle Creek Sanitarium by Dr. John Harvey Kellogg as a health food. (Courtesy Producers Peanut Company.)

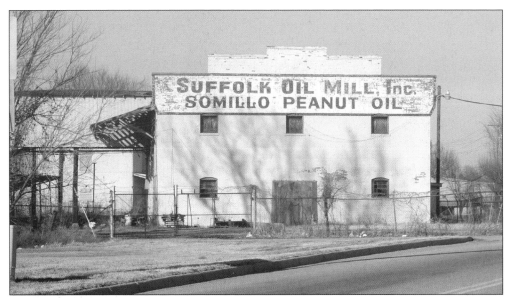

Somillo Peanut Oil Factory. The peanut fields brought a number of industries to Suffolk. In addition to peanut processors, who would clean, grade, and shell nuts, there were also peanut manufacturers, who would take raw peanut products and turn them into snack mixes, candy, oil, and more. Storage facilities also filled a niche. The factory for Somillo Peanut Oil sits vacant at the edge of East Suffolk in this 2004 photograph. (PEH.)

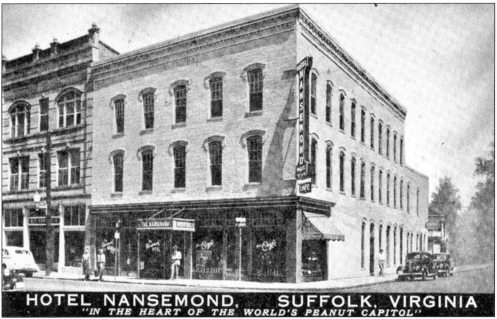

Hotel Nansemond, "In the Heart of the World's Peanut Capitol." Peanuts were good for business, even for those not in the peanut business, such as this postcard for the Hotel Nansemond, postmarked 1938, claims. With large companies like Planters Peanuts headquartered in Suffolk, the town never lacked for visitors. The card's back reads, "Good hunting, excellent golfing, bathing, boating, salt and fresh water fishing, few minutes drive from hotel." (TO.)

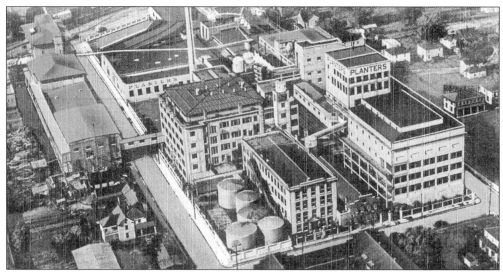

AIR VIEW OF PLANTERS NUT AND CHOCOLATE COMPANY. The back of this unpostmarked *c.* 1940 card reads, "Home of Mr. Peanut and the famous Planters Salted Peanuts. The largest manufacturers of Peanut Products in the world in the World's Largest Peanut Market—Suffolk, Virginia." Italian immigrant Amedeo Obici came to town in 1913 and opened Planters's Suffolk factory. The town was never the same. (TO.)

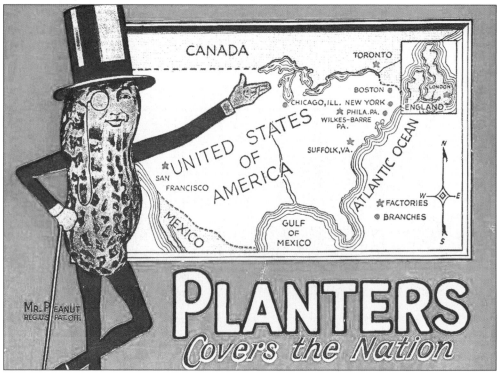

PLANTERS COVERS THE NATION. A jovial Mr. Peanut shows off his domain in this 1958 advertisement for Planters Nut and Chocolate Company. The ad shows the Suffolk headquarters; factories in Wilkes-Barre, San Francisco, Toronto, and London, England; and offices in New York, Chicago, Philadelphia, and Boston. (RFM.)

Three

AMEDEO OBICI AND PLANTERS PEANUT COMPANY

When Amedeo Voltejo Obici arrived in New York City from his native Oderzo, Italy, in 1889, the 11-year-old had about 75¢ in his pocket and spoke no English. Instructions tied to his coat told authorities he had an uncle, Vittorio Sartor, waiting for him in Scranton, Pennsylvania. The story of Obici unfolded much like a traditional Horatio Alger tale. After working hard at a series of jobs, he scraped up enough money to start Planters Peanut Company in 1906 with a friend, Mario Peruzzi. Obici's marketing savvy changed the way Americans thought about the lowly goober. Most of his suppliers came from farms around Suffolk, and in 1913, the majority of the operation was relocated there. Obici died in 1947, leaving a legacy much larger than his five-foot frame. Planters is now a division of Kraft Foods and still maintains a plant in Suffolk.

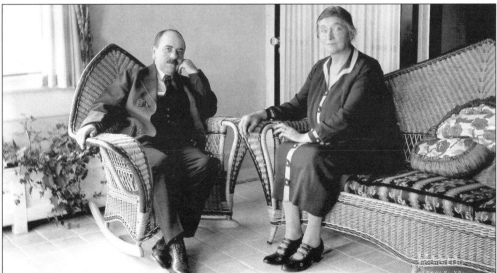

AMEDEO OBICI AND LOUISE MUSANTE OBICI. Both Amedeo and Louise were Italian immigrants who initially made their home around Wilkes-Barre. They married in 1920, taking residence in Suffolk in 1921. In 1924 they moved to Bay Point Farms, an estate just north of Suffolk. Here they sit in a parlor at their residence. "The woman I married gave me all the success I have known," Obici later said. (JD.)

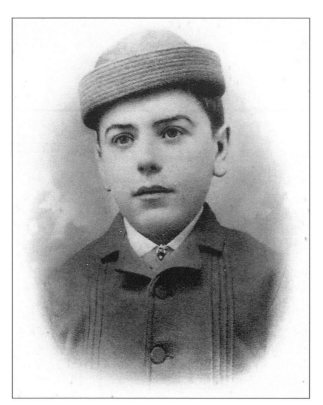

A YOUNG AMEDEO OBICI. This photograph of Amedeo Obici was taken when he was around 13 years old, about 1891. Obici came to America when he was 11 to live with his uncle in Scranton, Pennsylvania, and to work and raise money to bring his widowed mother and three younger siblings to this country. By 1895 he had saved enough money for their journey. (JD.)

A PORTRAIT OF THE OBICI FAMILY. This is likely the *c.* 1889 photograph Amedeo Obici brought with him to America of his family in his native Oderzo, Italy, a small town near Venice. To the left of his mother, Luigia Carolina Sartor Obici, are, counterclockwise, Frank, Angelina, and Elizabeth. Amedeo's father, Pietro Lodovico Obici, had died when Amedeo was seven. (JD.)

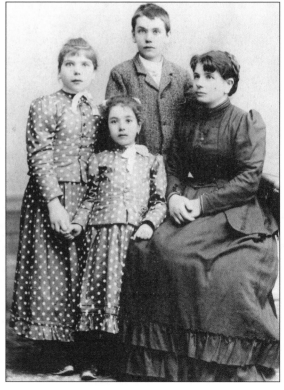

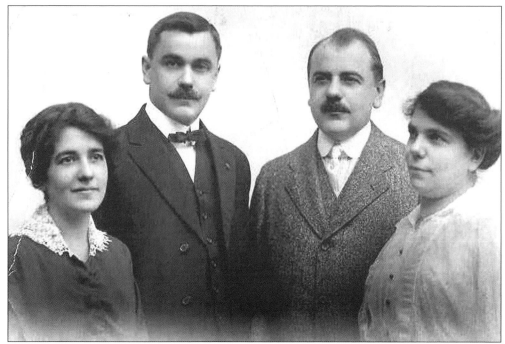

SIBLINGS OF THE OBICI FAMILY. Obici brothers and sisters gather for this family portrait, taken after the whole family had immigrated to America. From left to right are Elizabeth, Frank, Amedeo, and Angelina. Elizabeth would later marry Amedeo's friend and co-founder of Planters Peanuts, Mario Peruzzi. The family remained tight-knit throughout their lives. (JD.)

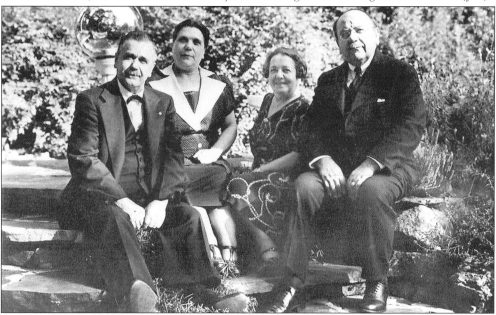

BROTHERS AND SISTERS IN THE OBICI FAMILY. This family portrait of the Obici brothers and sisters was taken on a weekend retreat in Pennsylvania. From left to right are Frank, Angelina, Elizabeth, and Amedeo. The Obici family kept strong ties to the Wilkes-Barre/Scranton and Suffolk areas. (JD.)

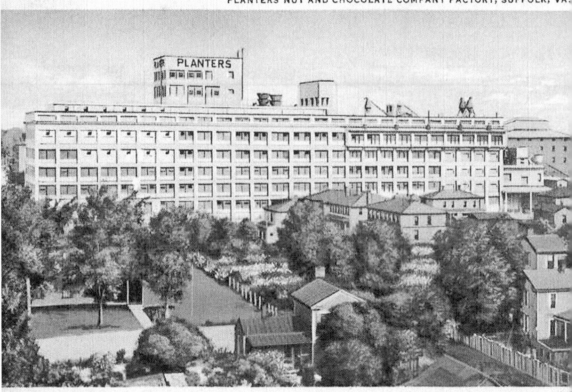

PLANTERS NUT AND CHOCOLATE COMPANY FACTORY. Amedeo Obici's entry into the peanut world began in 1896 when he opened his own fruit stand on East Market Street in Wilkes-Barre. He saw peanuts as a good investment, because they did not spoil as fast as other produce. He bought a peanut roaster for $4.50 and began selling nuts from a wagon pulled by his horse Old Dick. He became known as the Peanut Specialist in the area and developed an efficient and cost-effective method of blanching whole, roasted nuts, doing away with hulls and skins. Partnered with Mario Peruzzi, also an Italian immigrant, they formed Planters Peanut Company in 1906, employing six and utilizing two roasters. The name Planters was chosen because it sounded "important and dignified." The company became Planters Nut and Chocolate Company in 1908, when it began combining peanuts and chocolate to produce confections. By 1912 Obici realized his company needed to move closer to where the large, favored, Virginia-style nut grew to reduce middlemen and increase profits. He chose Suffolk, and factory operations began there in 1913. (TO.)

THE CRADLE. This early 20th-century photograph shows the first factory and headquarters for Planters Peanut Company in Wilkes-Barre. After coming to America to live with his uncle, a tailor, Obici worked in a cigar factory, with friends in the fruit-stand business and as a barkeep, and he later opened his own produce stand before settling on peanuts as his trade. (JD.)

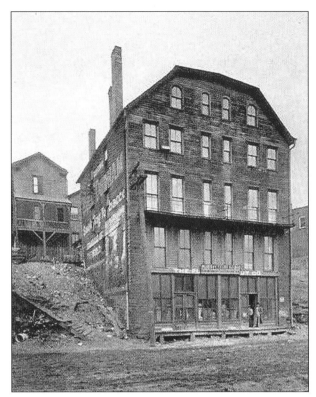

MR. PEANUT. Part of Obici's genius was advertising and marketing. He picked a drawing submitted in 1916 by Suffolk schoolboy Anthony Gentile as a mascot for the company and to "glorify the peanut." A commercial artist added the trademark cane, hat, and monocle. Mr. Peanut debuted in the *Saturday Evening Post* the same year. This vintage advertisement can be found in the Peanut Museum at Riddick's Folly in Suffolk. (PEH.)

ANTHONY GENTILE, CREATOR OF MR. PEANUT. At 14, this Suffolk schoolboy submitted a series of drawings of "peanut people" that caught the attention of Obici, and Mr. Peanut was born. Anthony received a $5 cash prize, but later Obici paid for his way through college and medical school, said Obici's niece, Jolyne Dalzell. (JD.)

MR. PEANUT, A NATIONAL ICON. Soon after Mr. Peanut came out in 1916, his likeness was everywhere. Obici used the spokesnut's likeness in advertisements and as giveaways, such as comic books, coloring books, pens, pencils, letter openers, whistles, and more. This Mr. Peanut decorates a vintage roaster at the Planters Peanut Center store in Suffolk. Today, Mr. Peanut has been "modernized" in commercials playing basketball and disco dancing. (PEH.)

BUSINESS MEETINGS. In the top photograph, from the mid-20th century, Mario Peruzzi, second from left, and Amedeo Obici, to the right of Peruzzi, are shown with Planters directors at Union Station in Suffolk after their "convenzione annuale," or annual convention, as written on the back by Obici. Obici identifies the man on the left as "il grasso Morgan uno de direttori" or "the fat one Morgan, one of the directors" and the man on the right as Driscoll, "direttore della fattoria in San Francisco," or "director of the farm in San Francisco." The bottom photograph is identified as "Planters Salesmen Jamboree, December 17-18-19, 1941, Suffolk, Virginia." While in town, Obici liked to entertain employees and guests at either his Bay Point Farm estate or the nearby Planters Club, which Obici built for business meetings and social gatherings. (JD.)

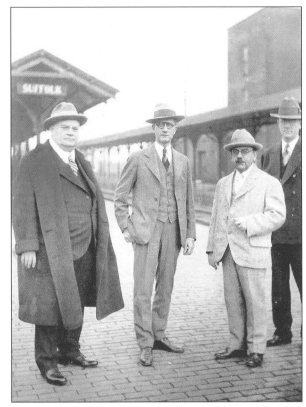

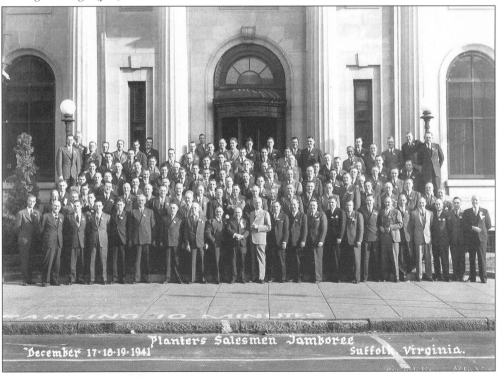

Planters Salesmen Jamboree
December 17·18·19·1941 Suffolk, Virginia.

MR. PEANUT STANDS GUARD. Mr. Peanut was everywhere in Suffolk during Planters's heyday, including the three-foot, cast-iron statues atop the warehouse in this *c.* 1941 photograph. Planters was an industrial giant, and its holdings would eventually include 36 buildings sprawled on 38 acres in Suffolk alone. Many were acquired through purchase, like the 1926 buyout of the John King Peanut Company and the 1927 procurement of the Old Dominion Peanut Company. (JD.)

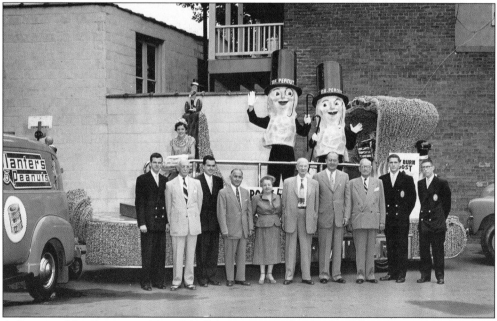

A PAIR OF MR. PEANUTS. Twin Mr. Peanuts are ready to greet folks in a *c.* 1940 parade in Wilkes-Barre. Planters's had factories from Wilkes-Barre and Suffolk to San Francisco and Toronto, Canada. The business, which began in Wilkes-Barre, grew substantially from a $100,000 bank loan in 1913 to purchase a small brick building, formerly Thompson Feed Company, on East Washington Street in Suffolk. (JD.)

CIVIC PRIDE. This 1957 photograph shows a Planters Peanuts float, ready for a parade in Suffolk. Planters has a long tradition of being active in the communities where it has factories. It was also a financial boon to areas like Suffolk. By 1925 Planters was funneling $8 million a year through the town, a figure that kept increasing. (SPF.)

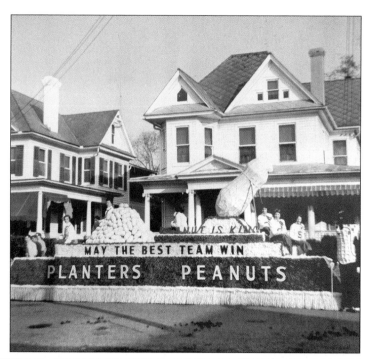

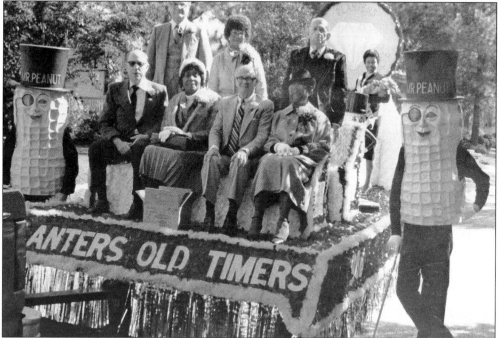

PLANTERS IN THE COMMUNITY. A late 1970s parade float is ready for the Harvest Festival, a prerunner of today's Suffolk Peanut Festival. On the float is Theodore "Ted" J. LoCascio, a 63-year executive with Planters. Hired by Obici in 1935, he was instrumental in shaping the company, serving as a plant engineer, chief engineer, plant manager, assistant to the president, and after retirement in 1977, consultant. He was Harvest Fest chairman in 1978 and 1979. He died in 1998. (SPF.)

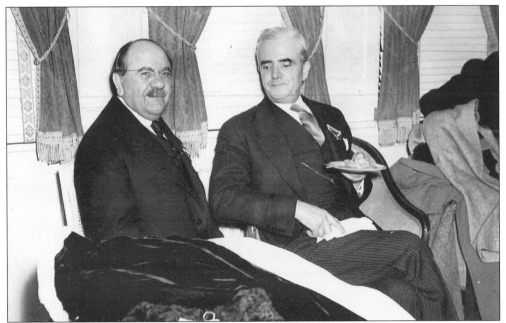

SUFFOLK, THE LITTLE CAPITAL. Because of the comings-and-goings of politicians and influential people during the peanut heyday, Suffolk was often referred to as the "Little Capital of Virginia." Here Obici chats with Virginia governor James H. Price at the Planters Club on January 29, 1941, on the occasion of the first National Peanut Festival. (TO.)

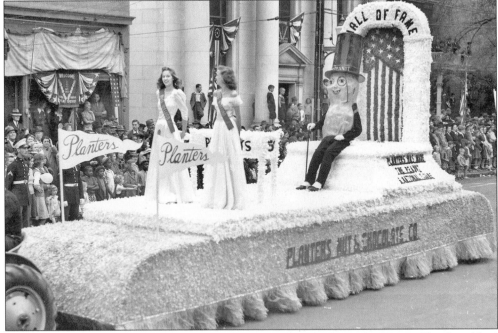

THE PEANUT KING AND MR. PEANUT. Obici was referred to as "The Peanut King" and had many great marketing ideas, like the "Nickel Lunch" cellophane bags of peanuts, affordable to the masses, and having Mr. Peanut be highly visible, as he is on this parade in the National Peanut Festival in Suffolk in January 1941. (TO.)

MR. PEANUT TODAY. From his inception in 1916, Mr. Peanut has remained a visible spokesnut for Planters, as seen in this mid-1980s photograph at the Suffolk Peanut Festival. Even after Planters changed hands many times over the years—it is now part of the Kraft Division of Altria, formerly Phillip Morris Co.—Mr. Peanut has remained synonymous with Planters. (SPF.)

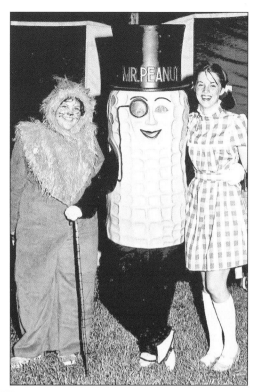

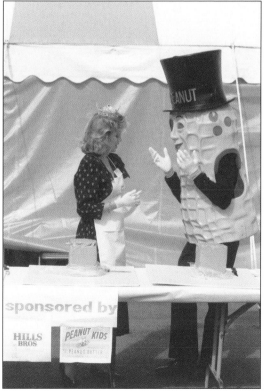

THE ROLE OF MR. PEANUT IS WIDE AND VARIED. From advertising icon to corporate goodwill ambassador, Mr. Peanut's role for Planters has been wide and varied. Mr. Peanut has always been a frequent site at the Suffolk Peanut Festival. Here Mr. Peanut consults with the festival queen before starting work on a sculpture made from peanut butter during one of the fete's activities. (SPF.)

45

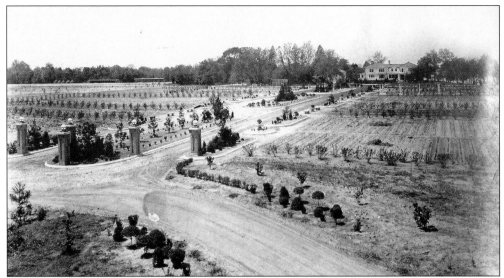

OBICI'S BAY POINT FARM. Amedeo and Louise Obici purchased Bay Point Farm near the community of Driver, just north of Suffolk, and along the shores of the Nansemond River. The 263-acre estate was a real working farm. For their home, a *c.* 1870 farmhouse was moved and expanded, using labor brought over from Italy for the job. The 7,000-square-foot house was made into a showpiece with stained-glass windows, parquet flooring, and beveled-glass front doors. The home had a wine cellar, fire alarms and a sprinkler system, and air conditioning. On the grounds were a swimming pool, ornate fountain, amphitheater, and a dock for Obici's yacht *Alura.* Being a working farm, Bay Point stocked 40 head of Guernsey cows. Now on the grounds of Sleepy Hole Golf Course, the facility is owned by the City of Suffolk. (JD.)

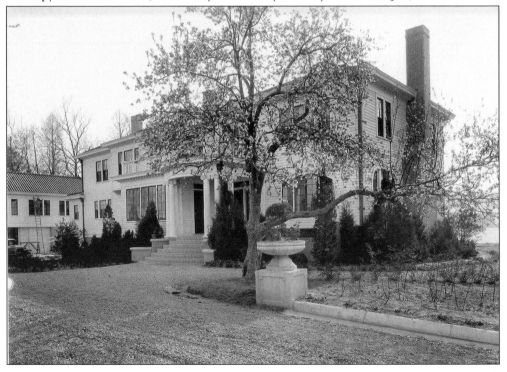

46

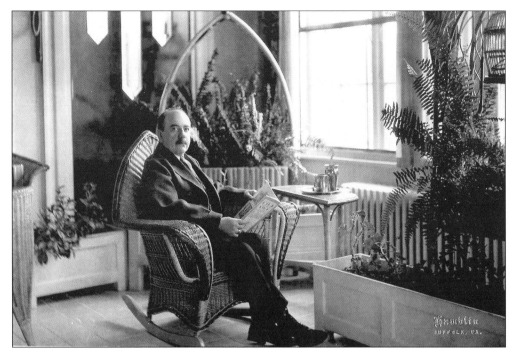

OBICI RELAXES IN HIS FRONT ROOM SOLARIUM. Amedeo Obici relaxes in the solarium of his Bay Point Farm home. The two-story structure was built in 1924. Located on the shores of the Nansemond River just north of Suffolk, the estate was a working dairy farm as well. A large porch opens on the back of the home, affording beautiful waterfront views. (JD.)

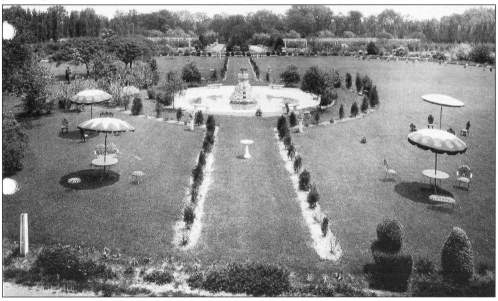

BEAUTIFUL GROUNDS AND FOUNTAIN AT BAY POINT FARM. Part of the charm of the Bay Point Farm estate was the landscaping, reminiscent of the Italian gardens of Obici's homeland. Obici, who purchased the land from Lelia A. Wagner, often entertained in a peaceful garden setting, complete with a fish-filled fountain in the center. After Obici's death, P.C. Hartman bought it, and later, the City of Portsmouth. It is now owned by the City of Suffolk. (JD.)

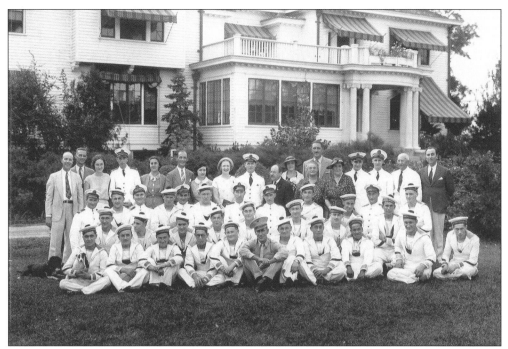

VISITORS TO OBICI'S BAY POINT FARM. Amedeo and Louise enjoyed entertaining at their villa-style home along the scenic Nansemond River. In addition to family, friends, and business associates, they would often invite civic groups and the military to visit, such as this group of sailors in port. The residence was furnished with valuable statuary, urns, antique and modern furniture, elaborate chandeliers (including one of Waterford crystal), china, and silverware. (JD.)

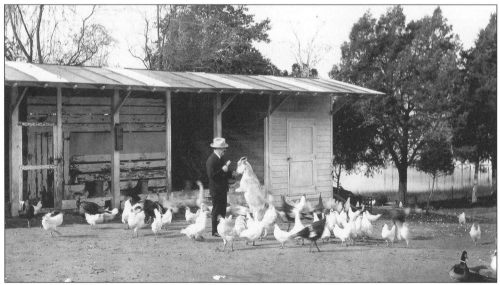

COMMUNING WITH NATURE. Many people don't realize that Obici's home was an actual working farm, with cows, chickens, goats, and other animals. Here Obici shares a moment with his pet goat Judy. Today the home is part of Sleepy Hole Golf Course and can be rented out for special events such as weddings. (JD.)

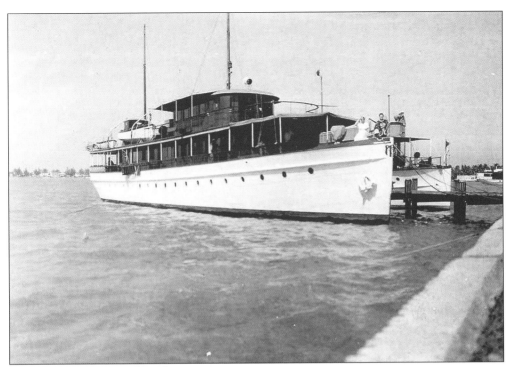

THE ALURA. Obici purchased this vessel from the widow of Charles Ringling, who had it custom built in 1922 and named it *Symphonia*. It was later renamed *Alura*. Obici enjoyed his yacht until it was commandeered during World War II and used for coastal waterways patrol. Obici did not retake the boat, and sometime in 1965 the original wooden superstructure was destroyed in a fire, leaving nothing but the steel hull. (JD.)

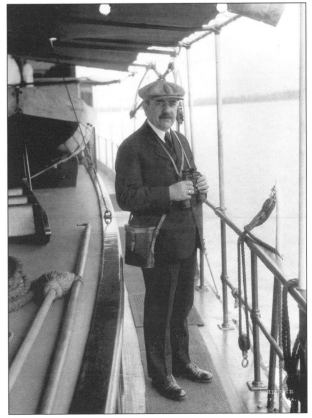

OBICI ON THE DECK OF THE ALURA. Obici kept his 195-ton yacht, the *Alura*, docked at his Bay Point Farm estate. It was piloted by Martin G. Ott. Guests enjoyed their stay, which included delicious meals and a movie after dinner. The vessel, partially restored after two fires, is now named the *Endure* and sits in a marina in Florida awaiting further renovations. (JD.)

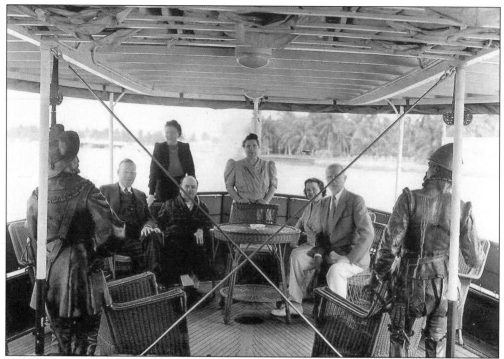

ALURA—ENCHANTRESS OF THE SEAS. Obici's yacht was luxurious, constructed of steel and teakwood with three decks. On the main deckhouse were a living salon, dining salon, butler's pantry, and owner's suite. Below deck were four guest staterooms, a cocktail lounge, galley, engine room, and crew quarters. On the bridge were the pilothouse and a spacious sun deck. The yacht was outfitted with two 120hp diesel engines, had a fuel capacity of 1,500 gallons, and could cruise from between 12 and 14 miles per hour. The *Alura* had an overall length of 120 feet. In the top photograph, Obici is surrounded by family, including sisters Angelina and Elizabeth, friends, and business associates on a trip to Miami in March 1940. (JD.)

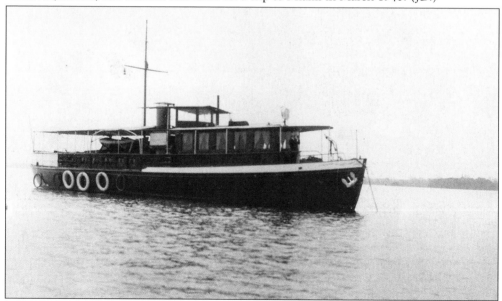

LOUISE MUSANTE OBICI. This is an early photograph of Louise Obici, taken while still living in Wilkes-Barre. Louise and Amedeo married in 1920 and moved to Suffolk in 1921. Louise was 13 years Amedeo's senior. She died in 1938 at age 74 after a lingering illness. It was her wish that a hospital be built in her name; plans for a facility in Suffolk began in 1942. (JD.)

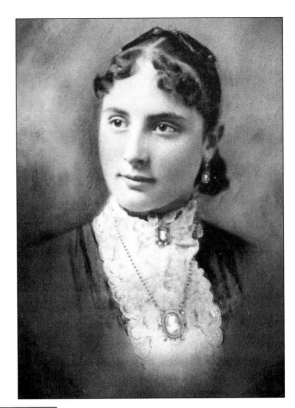

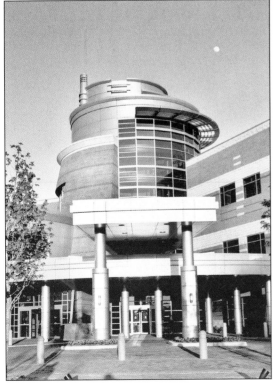

ENTRANCE TO THE LOUISE OBICI MEMORIAL HOSPITAL. Opening in 1951 on North Main Street in Suffolk, the hospital was constructed and continues to be funded by a trust set up by Amedeo Obici. It serves as a lasting memorial to Louise and as a service to the Suffolk community. When growth and change necessitated expansion, a new facility that opened in 2002 was built just north of the original hospital. (Courtesy Obici Hospital.)

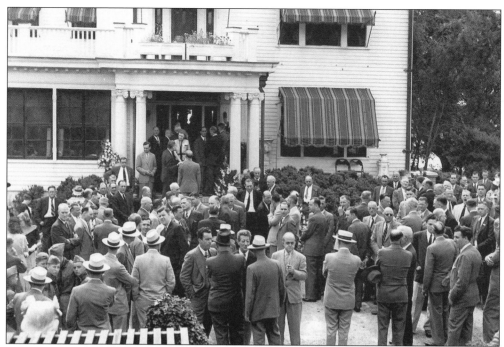

FUNERAL SERVICES FOR AMEDEO OBICI AT BAY POINT FARM. Obici, 69, died in May 1947 in Wilkes-Barre, where he had been hospitalized with a kidney ailment. Funeral services were held in Wilkes-Barre and at his Suffolk estate, shown in this photograph. His remains were temporarily placed in a mausoleum next to Louise in Suffolk's Cedar Hill Cemetery until Obici Hospital was built, and both were interned there. (JD.)

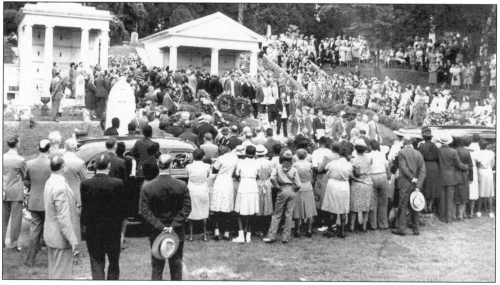

PALLBEARERS CARRYING THE CASKET OF AMEDEO OBICI. The casket was covered with a blanket of red and white carnations and surrounded by more than 140 wreaths and sprays. Note many attendees are wearing Masonic aprons. Obici was a 32nd degree Mason, Shriner, and member of the Elks. He was survived by his brother, two sisters, nieces, and nephews. He and Louise did not have any children. (JD.)

Four

EARLY PEANUT CELEBRATIONS

In January 1941, the first Peanut Festival was held. It included a parade, dances and balls, and coronation of a queen. A newspaper editor the morning of the first fete, on January 28, 1941, summed up the excitement in town: "Within a few hours the curtain will rise on Suffolk's first annual National Peanut Festival. . . .The whole city has been a beehive of activity. Cooperation has been had from every civic group, every private citizen and from the world at large. . . .The publicity which has been received already from all over the nation . . . [does] credit to Suffolk and the peanut industry." Some 10,000 folks turned out for the first Peanut Festival, a number that swelled to around 50,000 by the time the event was held again in October 1941. Today's Peanut Festival draws about 200,000.

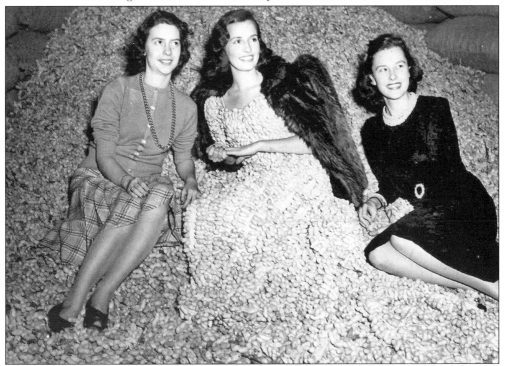

THE QUEEN AND HER COURT. The first Peanut Festival queen was New York actress and model Olive Cawley, resplendent in a gown of peanuts in the center of this photo, taken January 28, 1941. To the left is Flora McDonald, Miss North Carolina, and to the right is Henrietta Sadler, Miss Virginia. (TO.)

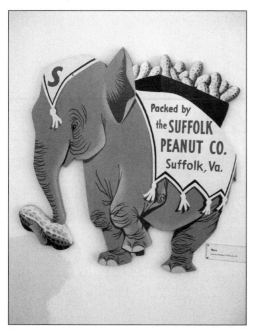 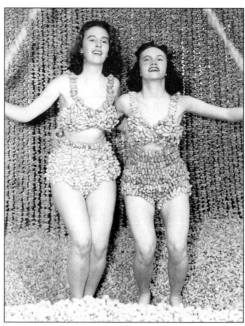

PEANUTS DRAW CURIOUS COMPATRIOTS. Elephants and frolicking girls in peanut bikinis are an odd mix brought together by peanuts. At left is an advertisement for Suffolk Peanut Company on display at the Peanut Museum at Riddick's Folly in Suffolk. Members of the queen's court dressed in legume-clad swimwear cavort at right. (RFM.)

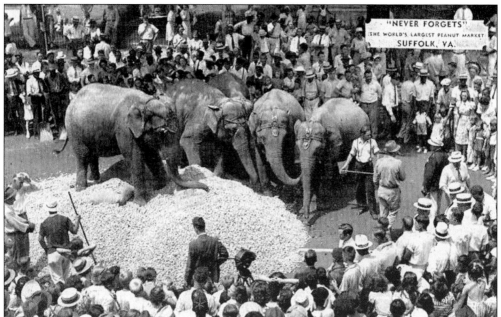

AN ELEPHANT NEVER FORGETS. That's the message on this 1941 postcard promoting Suffolk as the world's largest peanut market. In this promotional photo for the National Peanut Festival, elephants on loan from Barnum and Bailey's Circus help themselves to a ton of peanuts dumped in the middle of Main Street. The picture drew national press and further strengthened ties between pachyderms and peanuts. (Courtesy Lee and Henrietta King.)

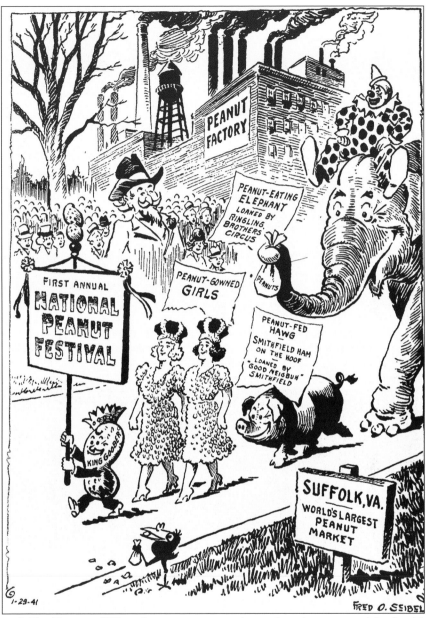

"**SUFFOLK'S BIG PARADE.**" This charming cartoon, chronicling the specter of the first National Peanut Festival, ran in the January 29, 1941, edition of the *Virginian-Pilot* and was drawn by *Richmond Times-Dispatch* artist Fred O. Seibel. Everyone in Suffolk burst with civic pride, including folks at Rose's Five-and-Dime Store, which ran this poem in an advertisement of the time: "'Twas Peanut Week in our town/ And roasted goobers crisp and brown/ In paper parcels big and round/ Sold all day long at a dime a pound. / Piled high in windows on the street/ They gave the passing throngs a treat/ The people paused to buy and eat/ Fresh peanuts salted, plain and sweet. / I've often dined and supped most well/ On peanuts roasted in the shell/ With glasses full of nature's brew/ They make a menu well to do. / These golden globules crisp and good/ I'd eat a bushel if I could/ I'd have enough to last me then/ 'Til Peanut Week shall come again." (TO, used by permission of *Richmond Times-Dispatch*.)

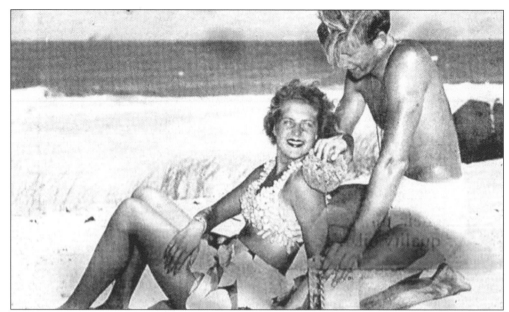

PEANUT OIL KEEPS THEM BEAUTIFUL. Just about any publicity stunt was used to draw attention to the Peanut Festival, including this October 1941 promotional photograph of Dale Price of Virginia Beach, who represented the resort city in the fete, having peanut-oil sunburn lotion slathered on her from John Henry Pierce of Suffolk. The caption reads, "Oh for the life of a life guard!" (RFM.)

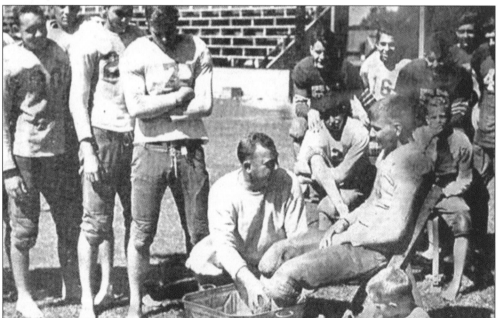

PEANUT OIL MAKES 'EM TOUGH. That's how the caption on this 1941 publicity photo ran. The paper reported, "Coach Al Hawkins of Suffolk High School shows another use for peanut oil as he applies it to toughen players' feet. The Suffolk boys, one of Virginia's best teams, will play a special game during the National Peanut Exposition to be held in Suffolk on October 30–31." (RFM.)

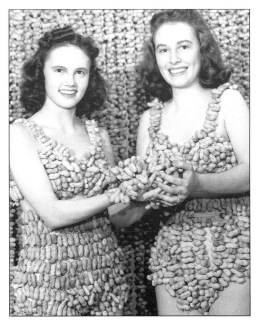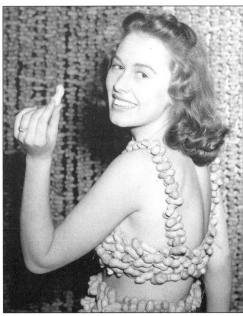

THE LOWLY PEANUT BECOMES A NATIONAL FIGURE. That was the caption headline for a publicity shot of these bikini-clad goober ambassadors. The newspaper reported, "Attractive young Virginia lasses, attired in bathing suits made of peanuts, will be among the participants in the pageantry connected with the National Peanut Festival in Suffolk, Va. The festival will be held Tuesday and Wednesday (Jan. 28 and 29, 1941), as the highlight of National Peanut Week." (RFM.)

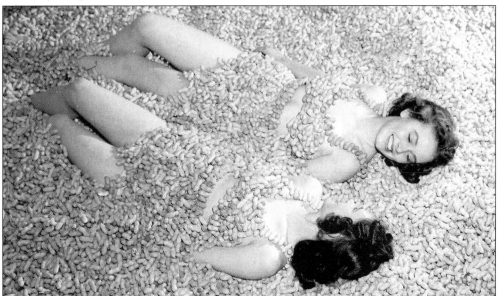

A ROYAL ACT. Part of the duties of Peanut Festival Queen was to cavort with the princesses, as the first "Queen Arachis Hypogea" (the botanical name for the peanut plant), top, does with one of her subjects. The first queen was Olive Cawley, which the newspapers reported as being a "famous model and screen actress." It appears the only film she ever did was an unaccredited role in *Vogues of 1938*. (RFM.)

PEANUT BEAUTY QUEENS. Another way to get the word out about peanuts and the Peanut Festival was through advertising media, such as this ink blotter used to sell the peanut products of Producers Peanut Company. Many of the blotters would feature festival queens and other "royalty" in slightly risqué photographs. (TO.)

TO BOLDLY GO WHERE NO PEANUT HAS GONE BEFORE. The whole town of Suffolk joined in with weeklong celebrations of the goober, including school activities like this game to see who can propel a peanut by their nose across the finish line first. Other events included a barn dance, parade, formal ball at the Planters Club, and carnival activities. (TO.)

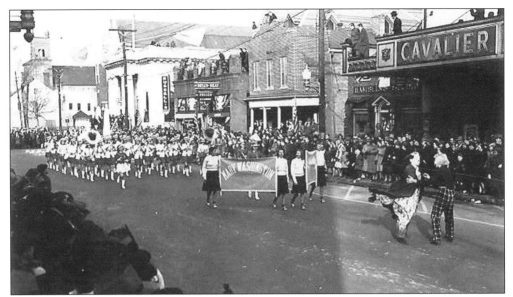

THE WORLD LOVES A PARADE. One of the features of the Peanut Festival continued even today is the parade through downtown Suffolk. Here the girls' band from Mary Washington College in Fredericksburg, Virginia—which took home second place—shows their stuff to throngs of folks lining the streets, pouring out of windows, and standing on rooftops in January 1941. Bands, marching units, floats, clowns, performers, and celebrities can all be found at the parade. (RFM.)

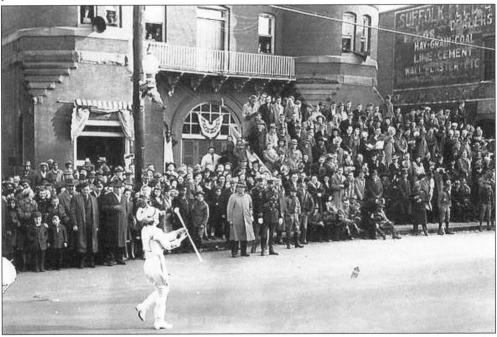

MAJORETTE ENTERTAINMENT. A wide assortment of entertainment draws folks out to the Peanut Festival parade, like this majorette twirling her baton on Suffolk's Main Street. The first National Peanut Festival was held in January 1941, and during the event, a few snow flurries actually fell. (RFM.)

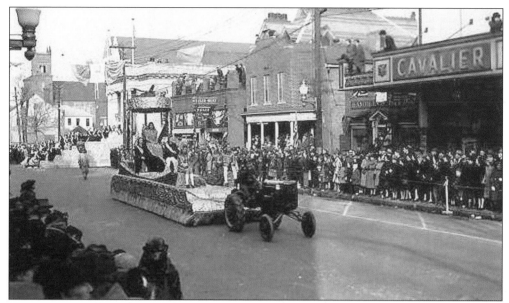

FLOATING BY. The *Richmond Times-Dispatch* reported of the first festival parade in January 1941, "The peanut parade will get started at 2 p.m., forming at Broad and Washington Streets. Across the street from the hotel is a newly constructed reviewing stand where dignitaries will sit to watch the procession. The parade will wind through the streets to Peanut Park, where the coronation of Miss Cawley as queen will take place." (RFM.)

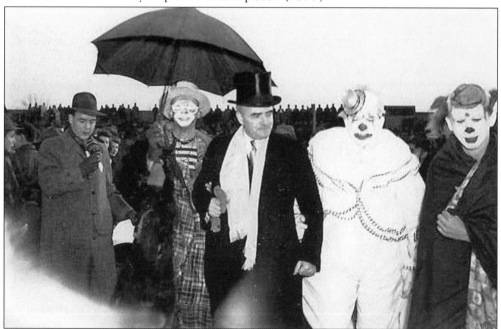

CLOWNING AROUND. Virginia governor James H. Price is stuck in the middle of these jokers and clowns at the first peanut festival in January 1941. The *Virginian-Pilot* reported, "Felix B. Adler, 'King of the Clowns,' the original Funny Felix of Ringling Bros., Barnum & Bailey Circus, will appear here Wednesday afternoon in the Peanut Parade of the peanut festival." The article said he brought a trained pig and several other clowns. (RFM.)

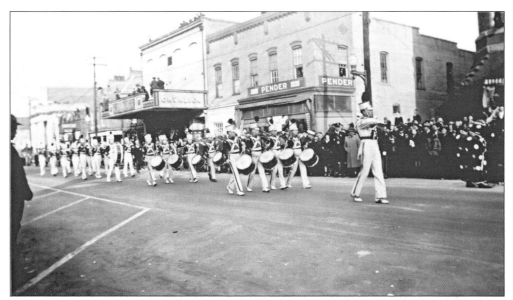

THE HOMETOWN HIGH SCHOOL BAND. The band from Suffolk High School marches down Main Street in the first Peanut Festival Parade in January 1941. The parade also included the introduction of the festival queen, Olive Cawley, and her entourage of "50 pretty princesses from dozens of communities and neighboring states. The queens were also paraded around town, touring peanut plants and attending social functions." (SPF.)

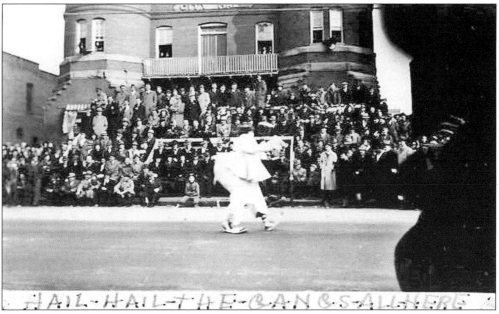

"HAIL, HAIL, THE GANG'S ALL HERE." That's the caption someone scribbled on the bottom of this January 1941 photo. Although the picture is blurred and the clown is unaccredited, it appears to be Suffolk dentist L.C. Holland, who clowned around in area festivals from the 1930s through 1950s and occasionally performed at the Ringling Bros., Barnum & Bailey Circus. His ducks Pink Lemonade and Crackerjack often accompanied Holland. (SPF.)

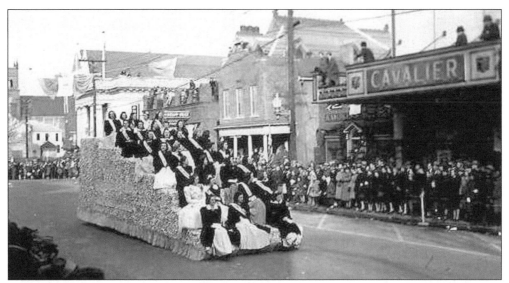

QUEENS FOR A DAY. On the occasion of the first festival in January 1941, the *Virginian-Pilot* reported, "The Chamber of Commerce building this morning was a mad riot as committees welcomed between 25 and 30 princesses from all over Virginia and North Carolina, the first vanguard of nearly 75 lovely girls expected to be in the court of the festival queen, Arachis Hypogea I." Here they are paraded down Main Street. (RFM.)

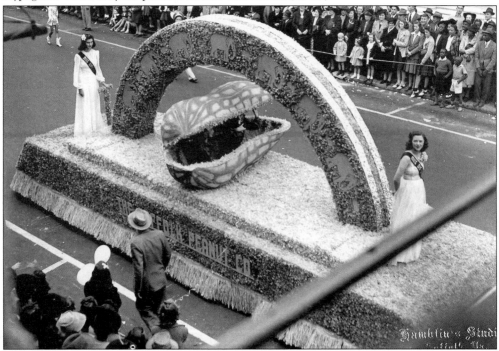

THE SUFFOLK PEANUT COMPANY FLOAT. The company was very involved with the celebration. Pres. John F. Pinner, son of the company's founder, greeted the festival queen and was her host during the fete. Reports the *Virginian-Pilot*, the queen "arrived this morning by train and was whisked by car to the home of Mr. and Mrs. John F. Pinner on Pinner Street where she will be entertained during her stay in Suffolk." (TO.)

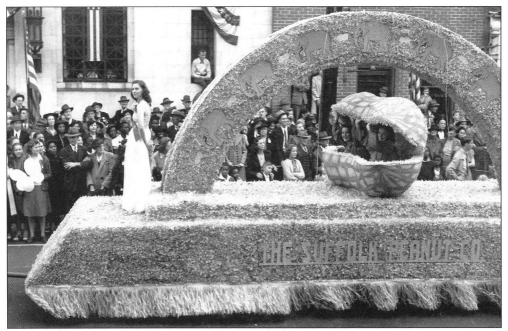

ANOTHER VIEW OF THE SUFFOLK PEANUT COMPANY FLOAT. Notice the incorporation of elephants in this themed float: they are parading across the arch over the giant peanut, hot on the pursuit of goobers. The January 1941 festival program, nodding to circus ties, noted, "Since P.T. Barnum's circus gave them their first national publicity, many new products have been made from the peanut." (TO.)

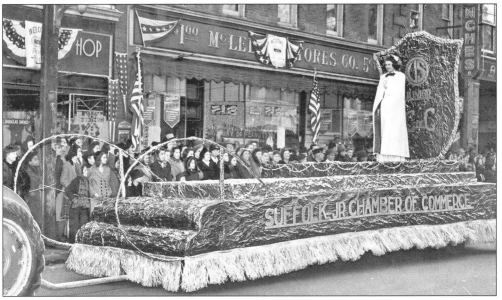

THE CHAMBER OF COMMERCE FLOAT. Festival royalty greets their subjects from this float. Notice the decorations in store windows along Main Street. From newspaper accounts, "The holiday spirit has already caught the city in its grip. Downtown the business establishments have red, white and blue bunting welcome signs ... In the store windows, displays of peanuts and peanut products tell the story of the rise of Suffolk's great industry." (TO.)

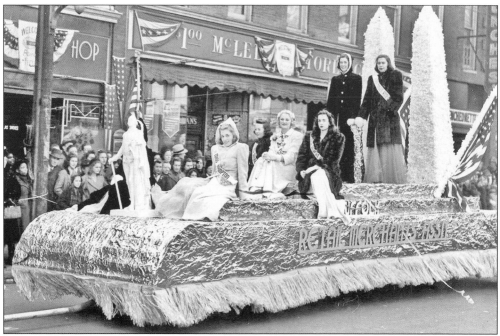

THE RETAIL MERCHANTS ASSOCIATION FLOAT. This float, complete with pageant beauties, rides down Main Street during the first National Peanut Festival. Suffolk planned a full outing for the princesses, including tours of peanut plants and "other interesting places in Suffolk," an all-day bingo party, a visit to the Mariner's Museum in Newport News, a reception and ball at the Planters Club, participation in the parade, and coronation ceremonies in Peanut Park. (TO.)

SCOUTING OUT THE PARADE. A Boy Scout assists in traffic and crowd control across from city hall on Main Street. The *Virginian-Pilot* described the parade, "At 2 o'clock with the streets massed with thousands, the great Peanut Parade including floats, bands and military units, will wend its way from Broad Street through the business section for the admiration of the public." (SPF.)

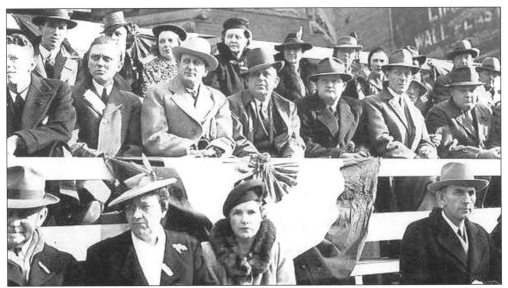

DIGNITARIES HUDDLE UP. Local, state, and national VIPs crowded the parade review stand during the first Peanut Festival, including Virginia governor James H. Price, North Carolina governor J. Melville Broughton, U.S. assistant secretary of agriculture Grover B. Hill, Suffolk mayor Jack Nurney, Planters Peanuts founder Amedeo Obici, and Suffolk Peanut Company president Jack F. Pinner, who also served as the festival chairman. Pinner promised the crowd to "outdo ourselves" at the next festival. (RFM.)

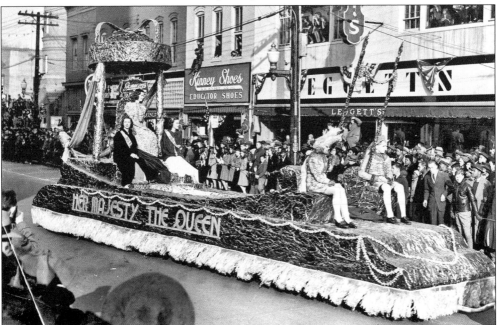

HER MAJESTY THE QUEEN. New Jersey girl Olive Cawley was decked out in a gown of goobers. Newspapers reported, "Dressed in her unique all-peanut costume, Miss Cawley . . . spent much of the afternoon in one of Suffolk's big peanut warehouses . . . [and] was 'shot' by the photographers . . . There was no heat in the building, and while the queen's teeth chattered in the cold, she told the newsmen she did not mind a bit." (TO.)

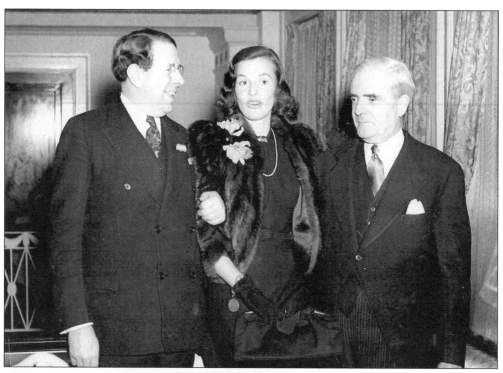

THE GOVERNORS AND THE QUEEN. From left to right are North Carolina governor J. Melville Broughton, Peanut Festival queen Olive Cawley, and Virginia governor James H. Price. Newspapers report after the parade there was "a buffet party for the princesses and distinguished guests on the yacht *Alura*, owned by President A. Obici, of Planters Nut and Chocolate Company, and the 'Peanut Party' dance at 10 o'clock in the Chorey Motor Company warehouses on South Main Street." (TO.)

A TOUGH NUT TO CRACK. The first night of the festival featured activities for "royalty" and the common folk, as newspapers reported: "At 9 p.m. a reception for visiting princesses will be held at the Planters Club and . . . the Peanut Planter's Ball, a square dance for the public, will start . . . at the City Auditorium with Norman Phelps and his string band furnishing music." (TO.)

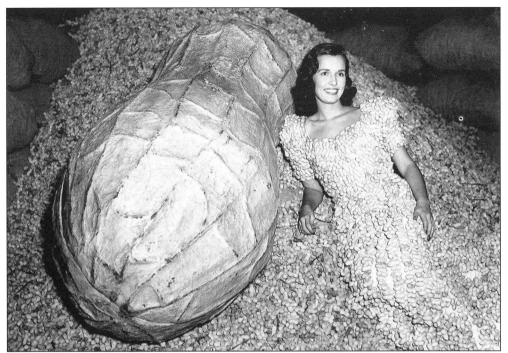

JUST DOING NUTTIN'. Peanut Festival queen Olive Cawley relaxes on a ton of goobers with a giant papier-mâche peanut in this publicity photo. Cawley and the princesses started the second day of the fete with a bingo party and a barbecue-press conference at the Planters Club before readying themselves for the big parade. (TO.)

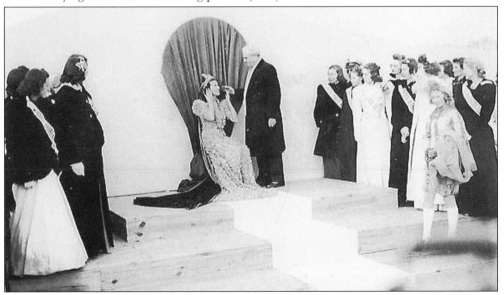

THE CORONATION OF QUEEN ARACHIS HYPOGEA I. Virginia governor James H. Price crowns Olive Cawley as the first Peanut Festival queen. The coronation took place at Peanut Park following the parade. There were some 50 princesses in the queen's court during the reign of the second festival queen, including Suffolkians Betty Cross, named Harvest Queen, and Mildred Sheffield, named Miss Suffolk. (RFM.)

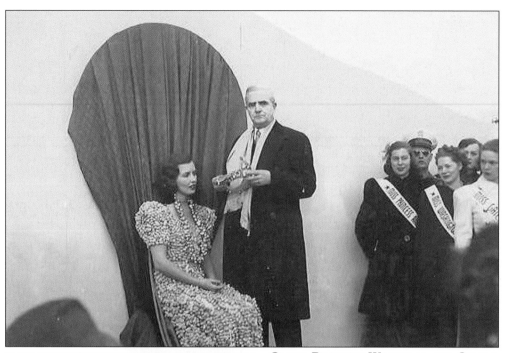

OTHER BEAUTIES WATCH AS THE QUEEN IS CROWNED. All the events over the two-day festival led up to this moment, as reported in the *Virginian-Pilot*, ". . . Suffolk made ready to welcome thousands to the city tomorrow to witness the Peanut Parade, Coronation and other outstanding events planned for the climaxing day of the two-day homage to the World's Largest Peanut Market." (RFM.)

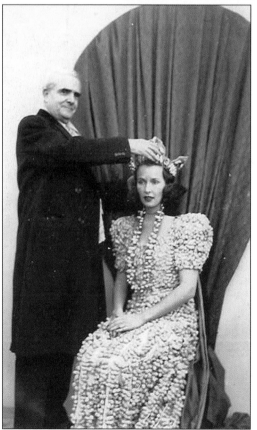

VIRGINIA GOVERNOR JAMES H. PRICE CROWNS OLIVE CAWLEY AS QUEEN. Some 10,000 folks attended the Peanut Parade, which made its way to Peanut Park for the coronation of the festival queen. Newspapers reported that newsreel cameramen from Universal, Pathe, and MGM studios recorded the event, as did more than 50 photographers from news services around the world. (RFM.)

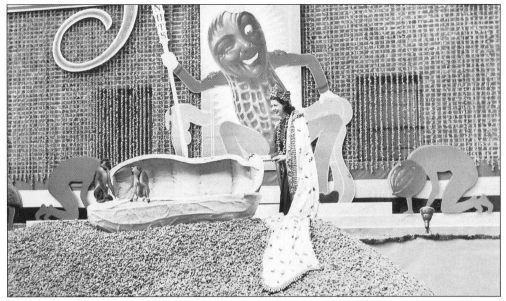

THE SECOND QUEEN, ARACHIS HYPOGEA II, REIGNS SUPREME. The second Peanut Festival was held October 30 and 31, 1941, and has been an autumn tradition since. Patricia Donnelly of Detroit, who had been the 1939 Miss America, was the second festival queen. Here she is in front of the Peanut Palace, a converted peanut warehouse. Olive Cawley returned to Suffolk to turn over her scepter to the new royal. (TO.)

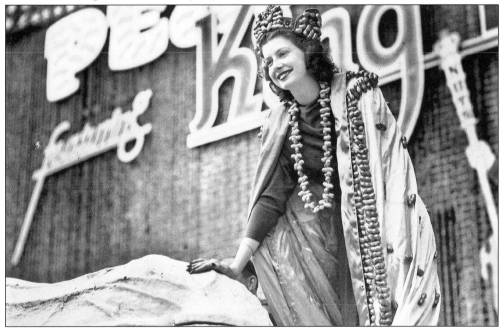

PATRICIA DONNELLY, THE SECOND FESTIVAL QUEEN. Newspaper accounts say Donnelly flew to town in a Pennsylvania Central Airlines plane and was greeted at the airport by dignitaries, including Planters Peanut's Amedeo Obici, who scattered roasted peanuts at her feet rather than the traditional rose petals. More than 50,000 came out during the second festival. Here is Donnelly at the Peanut Palace. (TO.)

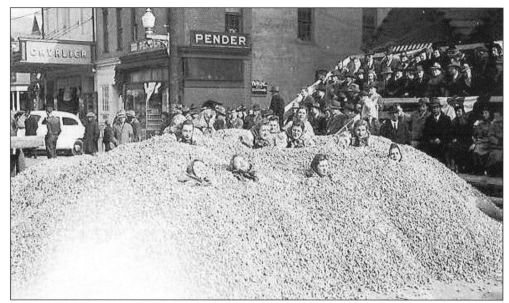

GOOGLES OF GOOBERS. Part of the publicity stunts for drawing attention to the early Peanut Festivals included the unloading of tons of nuts onto city streets to be enjoyed by elephants and, in the case of this photograph, workers from some of the city's peanut processing plants. No reports tell whether street sweepers cleaned up the mess or parade goers ate their way through the pile. (RFM.)

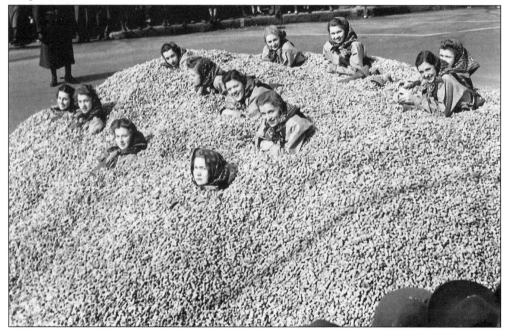

MORE WORKERS UNDER COVER. Plant workers from some of the city's peanut processing facilities pose for a photo buried under a ton of peanuts in the middle of the street during the first Peanut Parade. Peanuts were big business, reported a newspaper clipping of the time, "it is estimated that Suffolk, the 'World's Largest Peanut Market,' turned over $25,000,000 worth of peanut products (in 1940)." (RFM.)

THE PEANUT IS KING. A papier-mâché peanut is displayed during the first Peanut Festival. Peanuts had been a cash crop for about a half-century; according to newspapers, "Peanut growing had its inception in Virginia about a century ago and even then, it was only being done in a small way. Most of the peanut cleaning and marketing facilities in Virginia began around 1900, though ten years earlier Virginia began taking peanuts seriously." (RFM.)

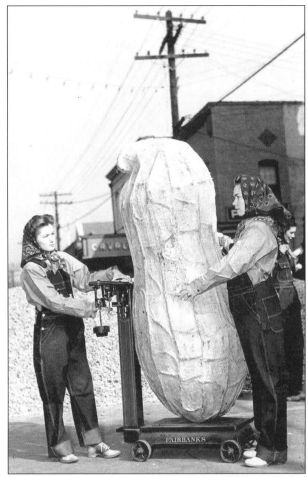

WORLD'S LARGEST PEANUT? A peanut facsimile promotes Suffolk as the leading peanut market. In homage to the claim, country radio station 1450 AM took the call letters WLPM as an acronym for World's Largest Peanut Market. The station went dark and has since moved to Virginia Beach with new call letters and a new format. (SPF.)

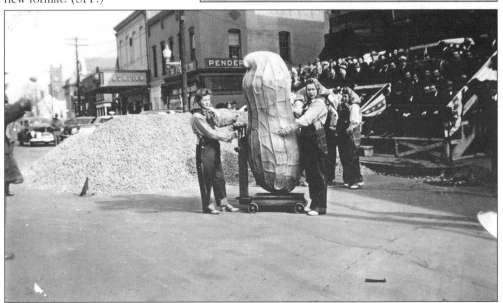

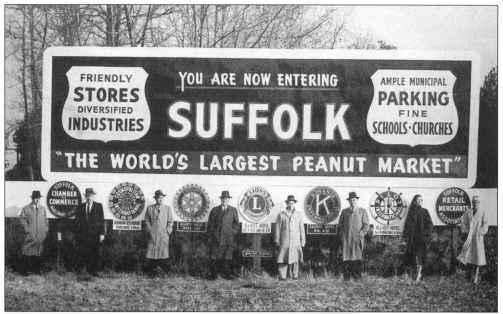

YOU ARE NOW ENTERING SUFFOLK. Community leaders pose in front of this billboard c. 1958, letting folks know they are entering the world's largest peanut market. The sign promotes friendly stores with plenty of parking, good schools and churches, and a diversity of business interests. The main industry was peanuts, which pumped millions of dollars into the local economy. (RFM.)

A COURTESY PASS TO THE SECOND PEANUT EXPOSITION. Following the success of the first Peanut Festival in January 1941, a second festival was held nine months later in October. The second festival included a queen, dances, and a parade but added a carnival in a converted peanut warehouse—the Peanut Palace—and a football game between University of Virginia and Virginia Tech at Foreman Field in Norfolk. (RFM.)

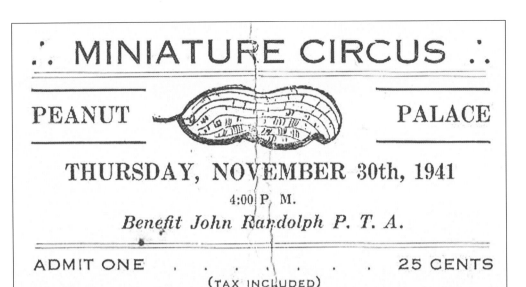

.:. MINIATURE CIRCUS .:.

PEANUT PALACE

THURSDAY, NOVEMBER 30th, 1941

4:00 P. M.

Benefit John Randolph P. T. A.

ADMIT ONE 25 CENTS

(TAX INCLUDED)

THE PEANUT PALACE. The second festival in October 1941 included the addition of the Peanut Palace, "an exposition house decorated with peanut designs and presenting on the inside exhibits from all phases of the peanut industry. The Peanut Palace will be made from a large peanut warehouse and is being planned by a committee headed by B.M. Birdsong. The ultimate aim of the committee is to have inside of the Peanut Palace a miniature circus and plans have already been made along that line for the appearance of a clown act and other special attractions. It is because of the close tie between the circus and peanuts that the Exposition committee is seeking to link the two together for the celebration." The top photo shows a ticket to the circus; the bottom photo shows the Peanut Palace. (RFM, TO.)

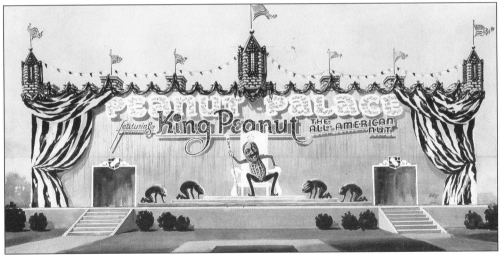

The Festival Program

First Day

Tour of Peanut Plants and other interesting places in and around Suffolk.

Reception for distinguished guests and the Press.

The Peanut Planters Ball in the City Auditorium.

Second Day

Tour of Peanut Plants and other interesting places in and around Suffolk.

Luncheon for distinguished guests.

2:00 P. M.—The "Peanut Parade"

Coronation of the Queen.

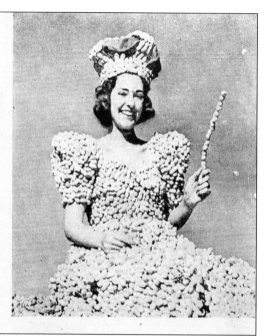

FESTIVAL PROGRAMS. Programs from the first two festivals give a hint to the pageantry and festivities the events bring. The top photograph is the program from the first festival in January 1941, and the second photograph is the program from the second festival in October 1941. Both featured the queen and court, dances and balls, and the Peanut Parade. The second festival added the Peanut Palace and miniature circus, as well as an exhibition football game between two state universities. Attendance also increased. The first festival drew a reported 10,000. That number had increased to 50,000 by the second festival. Now more than 200,000 attend Peanut Fest. (RFM.)

HIGHLIGHTS OF EXPOSITION PROGRAM

*

THURSDAY

11:00 A. M.—Official opening of the Peanut Palace including first performance of the Peanut Palace Miniature Circus.

3:30 P. M.—Official Opening of Peanut Exposition Carnival.

8:00 P. M.—Second performance of the Peanut Palace Miniature Circus in the Peanut Palace.

9:30 P. M.—The Peanut Harvest Ball, a Square Dance in a peanut warehouse opposite Peanut Park.

FRIDAY

11:00 A. M.—Third showing of Peanut Palace Miniature Circus in the Peanut Palace.

2:00 P. M.—The Peanut Parade.

4:30 P. M.—Coronation of Her Majesty, Queen of

ANNE ROLLINGS, OF SUFFOLK

Five

TODAY'S PEANUT FEST

The modern predecessor of today's Peanut Fest was celebrated September 21 through 24, 1978, in downtown Suffolk. Called Harvest Fest, the event featured a parade, a hot-air balloon event, a carnival, dances, concerts, and a festival queen. The fest would be a downtown tradition, with some activities later taking place at Peanut Park for the next several years, until the event moved to the Suffolk Municipal Airport. Celebrating a new home at the airport, fireworks were added to the event in 1981. In 1985 the festival officially became Peanut Fest. The festival includes carnival rides, games of chance, museum exhibits, children's activities, senior days, festival food, arts and crafts, a demolition derby, fireworks, and several stages of continuous entertainment. For four days each October, it draws some 200,000 folks. The festival has won the accolades of professional festival organizations and national magazines.

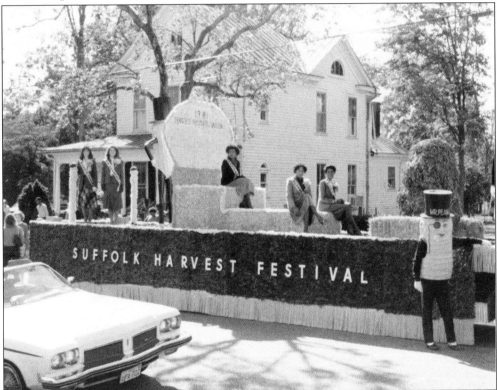

A TRADITION CONTINUES. A float from 1981 carries the festival queen, her court, and Mr. Peanut. The modern predecessor of today's Peanut Fest was celebrated in 1978 in along Main, Washington, and Market Streets and was called Harvest Festival. The name was changed to Peanut Fest in 1985. (SPF.)

PROCLAMATION

WHEREAS, The citizens of Dothan, Alabama, are celebrating their
 City's 100th Anniversary this year, and are living
 in the heart of peanut country and in the "Peanut
 Capital of the World", and

WHEREAS, the citizens of Suffolk, Virginia, well know the value
 of the world's number one agricultural nutritional
 food, the peanut, and

WHEREAS, all citizens who know the value and tasteability of
 peanuts must be good people who live in a region which
 has unparalleled economic potential, and

WHEREAS, both Dothan, Alabama and Suffolk, Virginia, have
 citizens who meet these criteria, and

WHEREAS, the citizens of Dothan, Alabama, and Suffolk, Virginia,
 believe they live in the "Peanut Capital of the World",
 and

WHEREAS, the most important thing is that both of our cities
 are promoting a very worthwhile product which helps
 farmers in both areas of this great country.

NOW, THEREFORE, I, Larry Register, Mayor of the City of Dothan,
 Alabama, do hereby proclaim that the citizens of
 Suffolk, Virginia, and the citizens of Dothan, Alabama,
 shall consider themselves as in the same family of
 God, and should visit back and forth and forever be
 good friends.

IN WITNESS WHEREOF, I have hereunto set my hand and caused the
Seal of the City of Dothan, Alabama to be affixed this the 26th
day of October, 1985.

SEAL

 Larry Register
 Mayor

Attest:

Delma Lee
City Clerk

A PROCLAMATION OF MUTUAL ADMIRATION. Peanuts grow best where the soil is sandy, rich in calcium, and warm. To produce a good crop, 120 to 160 frost-free days are required. That means that the majority of this nation's peanuts come from the southeastern United States. According to the Virginia-Carolina Peanut Promotions, the major peanut producing states are Virginia, North Carolina, South Carolina, Georgia, Florida, Alabama, Texas, Oklahoma, and New Mexico. Some varieties grow best in different parts of the country. The large, gourmet, Virginia-style nut grows best in Virginia and North Carolina, while the smaller Spanish style grows best in more southern states. And of course, everyone claims to be the biggest and the best. There is also a peanut festival in Dothan, Alabama, a city that brags to be the peanut capital of the world. Some good-humored fun can ensue between Suffolk and Dothan, but this proclamation by the City of Dothan seems to say everyone agrees to disagree. (SPF.)

76

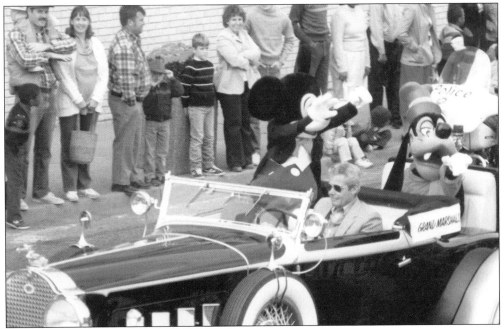

NO GOOFING OFF. Disney favorites Mickey Mouse and Goofy are seen in this 1986 photograph as grand marshals in the Peanut Festival parade. Thousands lined Washington and North Main Streets to get a look at the pair. Later, Mickey helped out during the peanut-butter sculpture contest. (SPF.)

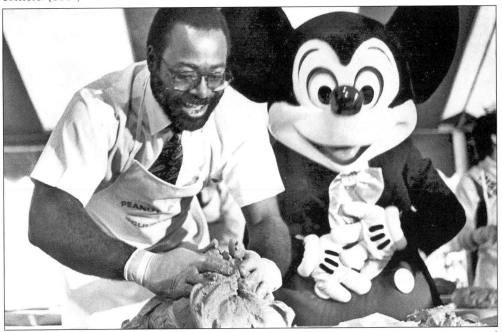

THERE'S A MOUSE IN THE HOUSE. In this 1986 photograph Mickey Mouse is seen giving moral support during the peanut-butter sculpture contest. Mickey and Goofy served as grand marshals in the Peanut Festival parade, as well as the likes of Elizabeth Taylor, Maralyn "Mad Dog" Hershey from the CBS television reality show *Survivor*, and Don Meredith. (SPF.)

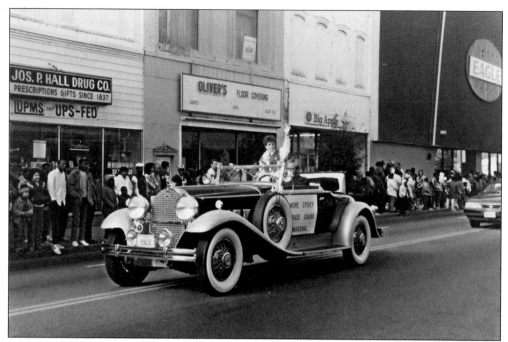

A GOLD MEDAL PEANUT FEST. Local girl and Olympic gymnast Hope Spivey was the grand marshal in the 1988 Peanut Fest parade and a participant in the peanut-butter sculpture contest. Born in nearby Norfolk, Spivey and her family moved to Suffolk when she was 12 years old. Through training and competitions, she made the 1988 U.S. Olympic team. In 2004 she was inducted into the Virginia Sports Hall of Fame. The Peanut Festival has had a tradition of pairing athletes and athletic events with celebration of the legume, including a road race, golf tournament, and volleyball tournament. (SPF.)

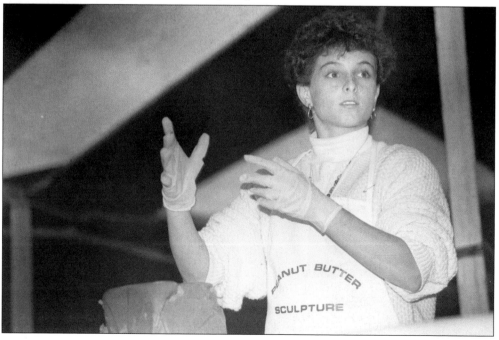

AN A-PEELING PART OF PEANUT FEST.
One of the kickoff activities for Peanut Fest is the Suffolk Ruritan Club Shrimp Feast, traditionally held at the festival site the first night of the four-day fete. Upwards of 5,000 folks show up to chow down on shrimp, barbecue, chicken, cole slaw, potato salad, and rolls; listen to a little music; and enjoy some beer. The feast is a fund-raiser for the community service organization. (SPF.)

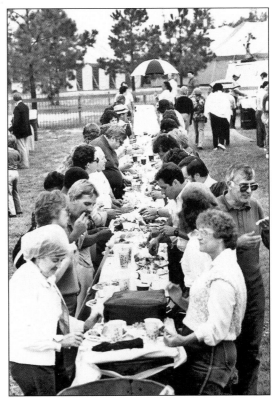

A PLACE TO SEE AND BE SEEN.
Celebrities and politicians are often seen at Peanut Fest. In this 1988 photograph Chuck Robb, one-time Virginia lieutenant governor, governor, and United States senator, chats with one of his supporters during the Suffolk Ruritan Club Shrimp Feast. Other politicians that have made appearances at Peanut Fest or related events include Sen. John Warner, senate candidate Oliver North, and Gov. Mills Godwin. (SPF.)

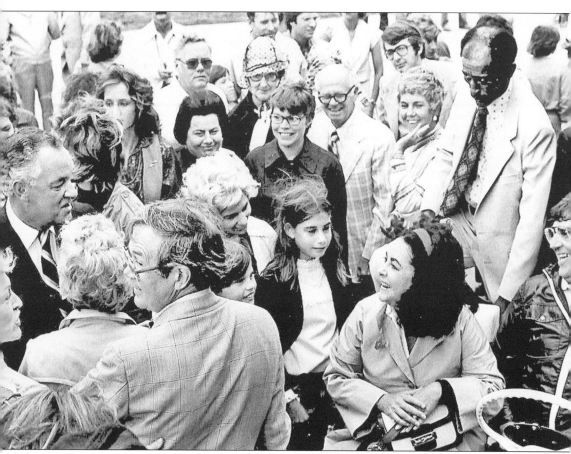

A QUEEN OF THE SILVER SCREEN. When Harvest Fest, the modern predecessor of today's Peanut Fest, first got started in September 1978, the fete had two queens: Theresa Ann Jackson, a student from John F. Kennedy High School, was voted by the general public as Fest Queen— but there was also a queen of the silver screen. Elizabeth Taylor, married to Virginia senator John Warner, milled about, meeting and greeting star-struck Suffolkians. She and Warner, who has appeared at several previous Peanut Fests, were married from 1976 to 1982. In this photo, Taylor is seen greeting crowds and talking to Gov. Mills Godwin, in the far left of the picture. Folks who remember meeting Taylor at that year's Harvest Fest recall her as being friendly, approachable, and accommodating. (SPF.)

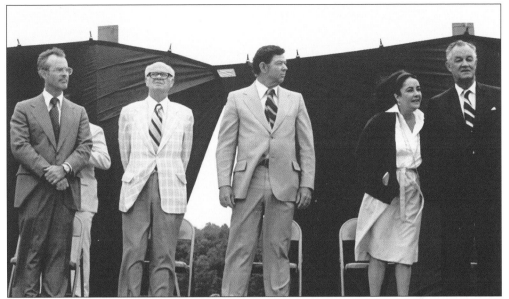

ELIZABETH TAYLOR TAKES THE STAGE. At the right of this 1978 photo, Elizabeth Taylor stands with Virginia governor Mills Godwin. Many celebrities have taken part of the festival, including Frank Gifford as parade marshal in 1979 and Brooks Robinson in 1980. Other grand marshals included Don Meredith in 1982, Mickey Mouse in 1986, and Olympic gymnast Hope Spivey in 1988. (SPF.)

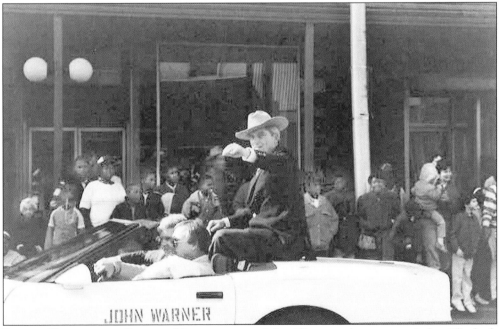

RIDING HIGH IN THE SADDLE. Virginia senator John Warner, who was married to Elizabeth Taylor from 1976 to 1982, acts as parade grand marshal for the Peanut Fest. Senator Warner started his 25th year of service in the Senate in 2003 after being elected to his fifth term in 2002, making him one of the longest-serving U.S. senators in the history of the commonwealth. (SPF.)

PEANUT FEST PARADE FROM THE LATE 1980s. The Peanut Fest parade has been a longstanding tradition in Suffolk, dating back to the original celebration in the 1940s. More than 200 units wind their way through downtown, including floats, bands, clowns, and festival queens. The parade is held the Saturday before the festival, and activities are free. In this picture, P-Nutty, the festival mascot, can be seen waiving to the crowd. (SPF.)

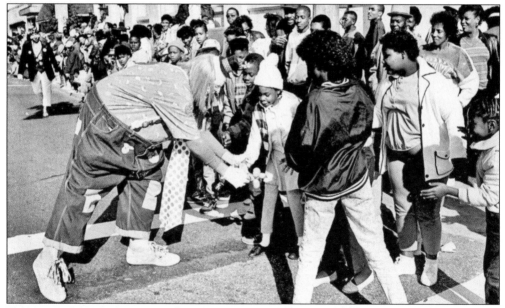

TAKING IT TO THE STREETS. There are many fun antics going on during the peanut parade, such as clowns entertaining the crowds lined up along the streets. In this 1988 photograph, clowns thrill the kids by making and giving away balloon animals. Later in the parade, the crowd is showered with peanuts by floats passing by. (SPF.)

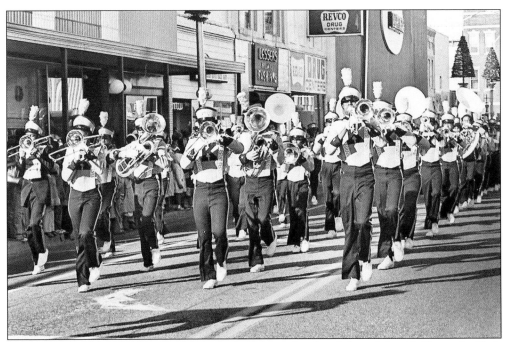

HORN-BLOWING TOE-TAPPING ENTERTAINMENT. The band from John F. Kennedy High School performs during a Harvest Festival parade in the late 1970s or early 1980s. Here they are marching down Washington Street. Today, the parade takes place the Saturday before Peanut Fest, getting folks excited about the upcoming events of the next week. (SPF.)

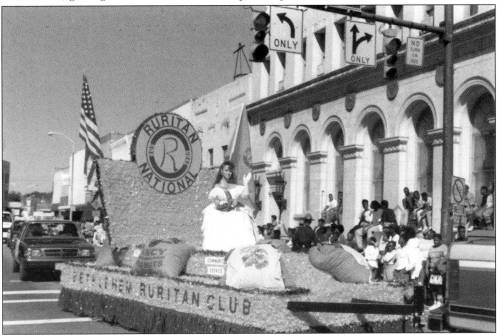

ELABORATE FLOATS AND BEAUTY QUEENS. A Southern belle rides on the Bethlehem Ruritan Club's float in this early 1980s photograph of the festival parade. Local civic groups and businesses create many elaborate floats following the lead of the festival's theme. (SPF.)

FOLKS LINE UP FOR THE PEANUT PARADE. Some 50,000 people arrive early in the morning for the 10 a.m. start of the Peanut Fest parade. Participants arrive even earlier, getting ready to ride floats, march, and otherwise help put on the show. Judges and other dignitaries pile into seating, close to the same location that review stands were placed for the parade in the 1940s. Music from bands across the region play, including those from the three Suffolk schools, Lakeland and Nansemond River High Schools and Nansemond-Suffolk Academy. Cars, trucks, horses, and floats make their way for about one-and-a-half miles along West Washington Street and turn north onto Main Street, cutting through the heart of downtown. Always popular are the Shriners with their miniature cars. In this early 1990s photograph, folks can be seen lined up for the parade, chatting with clowns, and buying peanut-shaped balloons. (SPF.)

GOOBER GANG GIVES
GOODWILL. The Goober Gang
acts as the official goodwill
ambassadors for Peanut Fest.
Organized by then-fest
chairman Eley Duke in 1986,
the gang comprises about 30
teenagers from area schools.
The minimum gang age is 13.
Goober Gang members work in
shifts every day of the festival,
from open to close, from their
"headquarters," a red Norfolk
& Western caboose placed in
the middle of the fest grounds
in 1986; the caboose is also a
popular meeting place. Goober
Gang members, selected by
teachers at their school, help
out with the parade by meeting
and greeting fest-goers, handing
out free cupfuls of peanuts,
answering questions, and
handing out programs. In
addition to the kids, some 200
volunteers help out with
Peanut Fest, including an all-
volunteer board. (SPF.)

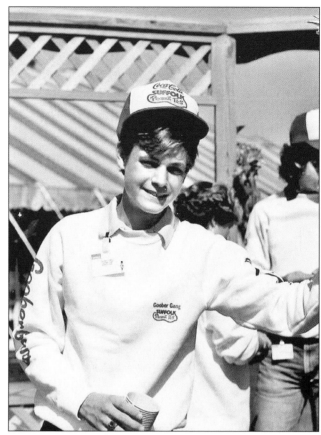

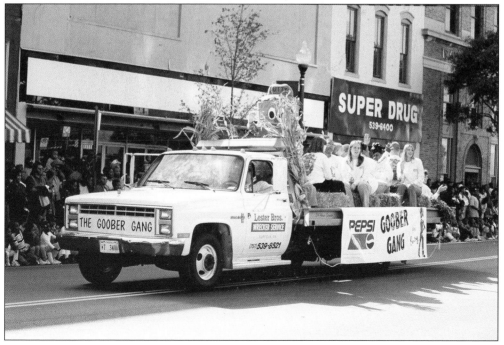

STANDING TALL. Peanut Fest fills four days with a carnival atmosphere that includes rides, games of chance, and funny folks, like this man on stilts—Jim Edmondson. Jim (who also juggles and rides a unicycle), like some of his clown counterparts, walks around and makes sure everyone is having a good time. He is escorted by a member of the Goober Gang. (PEH.)

NOW WHAT? That seems to be the question Peanut Fest Queen Billie Jean Savage, who was representing Nansemond-Suffolk Academy, is asking in this late 1990s photograph. As part of her queenly duties, Billie Jean was a contestant in the peanut-butter sculpture contest. This picture clearly shows what the 12-inch-by-12-inch block of peanut butter looks like before participants start carving into it. (SPF.)

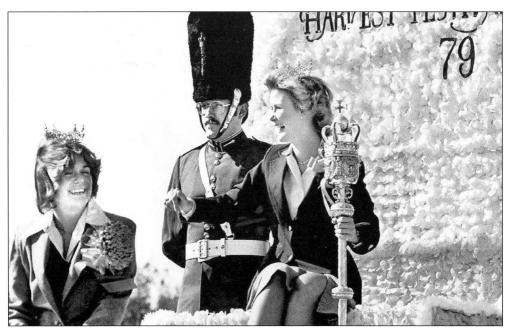

STANDING GUARD OVER THE QUEEN. A sentry watches over the 1979 Harvest Fest queen and court. The modern predecessor of today's Peanut Fest started in 1978 and was called Harvest Fest. The event was kicked off by Lt. Gov. Charles Robb and featured a parade, a hot-air balloon event, a carnival, dances, and concerts. The festival queen was voted by the general public. (SPF.)

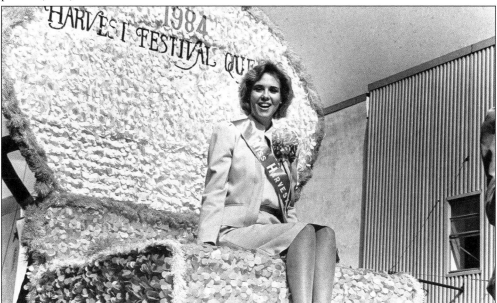

IT'S GOOD TO BE QUEEN. That seems to be what this 1984 Harvest Festival Queen is thinking. Since the first Peanut Fest queen, Olive Cawley, in 1941, the title has been bestowed to scores of young ladies, and along with it, the task of representing the festival and the city of Suffolk. The queen and princesses are treated to a luncheon and fashion show put on by the Pilot Club of Suffolk. (SPF.)

QUEEN FOR A DAY. In addition to such royal duties as participating in the peanut-butter sculpture contest, the queen and court also ride in the parade and mingle with crowds at the fest. The search for a queen starts in the spring when juniors at Lakeland and Nansemond River High Schools, as well as Nansemond-Suffolk Academy, are invited to write an essay on what Peanut Fest means to them. (SPF.)

A SCULPTURE FIT FOR A QUEEN. Peanut Fest queen Billie Jean Savage chats with country radio personality Joe Hoppel about her entry in the peanut-butter sculpture contest in this late 1990s photograph. Hoppel, a personality from KICK 93.7 FM, has long been the emcee for the event. Notice the apron contestants are wearing: this is a highly sought-after collectible given to contestants, imprinted with tasty peanut recipes. (SPF.)

MAMA MIA, THAT'S PEANUT BUTTER. Alessandro Salvada, visiting as a part of the Sister City program between Suffolk and Oderzo, Italy—the birthplace of Amedeo Obici, founder of Planters Peanuts—tries his hand during a peanut-butter sculpture contest in the late 1990s. Over the years, others with Sister City have visited, too—including partners from Suffolk County, England, one of whom created a peanut-butter castle. (SPF.)

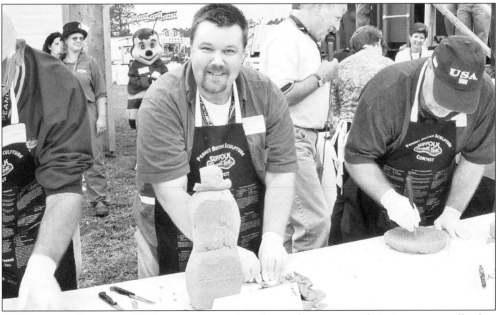

A FAMILIAR OUTLINE. Without even turning the sculpture around, it is easy to tell what Patrick Evans-Hylton is carving in this photograph of the 2002 peanut-butter sculpture contest. Complete with a top hat, monocle, and cane made from peanut butter, Evans-Hylton took first prize with his rendition of Mr. Peanut. Contestants have a butter knife and 20 minutes to complete their carving. (PEH.)

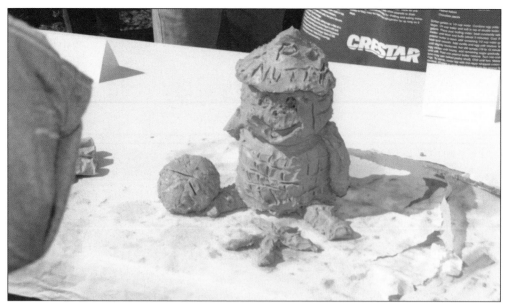

AND THE WINNER IS . . . P-NUTTY. This rendition of Peanut Fest mascot P-Nutty gave fest chairman Wayne Boyce a blue ribbon in the 2000 peanut butter sculpture contest. The beach ball and starfish are a nod to the "beach" created at the fest site that year that included a pile of sand and volleyball. This sculpture was the inspiration to carve a 2,500-pound version in 2003. (SPF.)

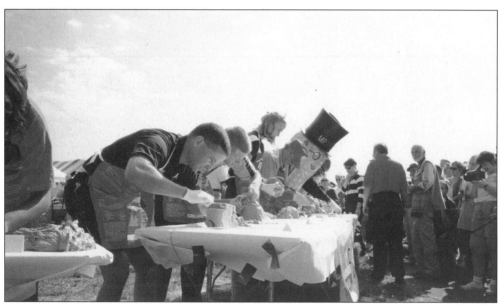

SOME SERIOUS COMPETITION. One of the most popular events at Peanut Fest is the peanut-butter sculpture contest, which started in the early 1980s. The contest has about 15 participants, which includes the queen and her court, the festival chairman, community leaders, and either P-Nutty or Mr. Peanut. Three judges select work based on creativity and neatness. (SPF.)

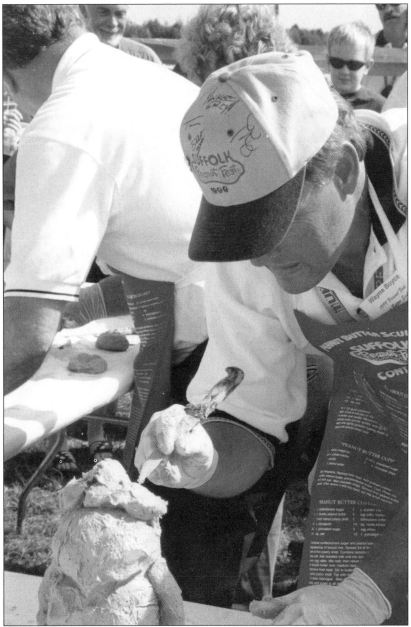

CONCENTRATION. Festival chairman Wayne Boyce works on his peanut-butter rendering of P-Nutty in this 2000 photograph; he won first place. It seems like a sticky proposition—creating a work of art from peanut butter—but it is possible. The Peanut Fest chairman, the Peanut Fest queen and princesses, city representatives, media personalities, and other dignitaries show off their carving skills as they sculpture a 12-inch-by-12-inch block of peanut butter. The peanut butter is a special mixture provided each year by Suffolk-based Producers Peanut Company. The sculptures are judged and ribbons are awarded to the top three peanut-butter productions. Some guidelines in using peanut butter as a sculpting medium are to practice beforehand using modeling clay; carve the peanut butter, don't try to work it with your hands; work fast and with a plan; and hope for a cool overcast day. (SPF.)

THIS IS NOT YOUR PLAYSCHOOL'S PLAY-DOH. The budding beauty queen in this photo is about to find out that playing with a block of peanut butter is not the same as craft clay. "You get an 85-degree day with high humidity, and you can't do anything with the stuff," said Peanut Fest Executive Director Linda Stevens. She also admits that watching contestants in the peanut-butter sculpture contest struggle is part of the fun. (SPF.)

SO MUCH PEANUT BUTTER, SO LITTLE TIME. Not only is there the pressure of coming up with a prize-winning design, there are also the added stresses of carving out a slab of peanut butter under the watchful eyes of the crowds in 20 minutes or less. This photo from 2000 shows peanut-butter sculpture contestants trying to achieve their peanut Zen and overcome those obstacles. (SPF.)

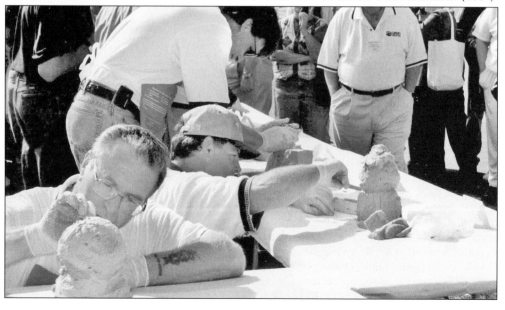

NO, THEY DO NOT GROW ON TREES. Lots of colorful characters make the rounds on Peanut Butter or Peanut Brittle Lane, adding to the carnival atmosphere of Peanut Fest, including P-Nutty, Mr. Peanut, Buddy McNutty, and this peanut guy, who probably gets asked all the time if peanuts grow on trees. (SPF.)

PEANUTUS HUMUNGOUS. This 32-foot-tall goober drew lots of attention at the 2002 Peanut Fest. With an appeal similar to the Oscar Meyer Weinermobile, this giant nut, owned by the National Peanut Board, travels around the country promoting the legume. A series of exhibits promoting the peanut augments the chef giving away samples and prizes. (PEH.)

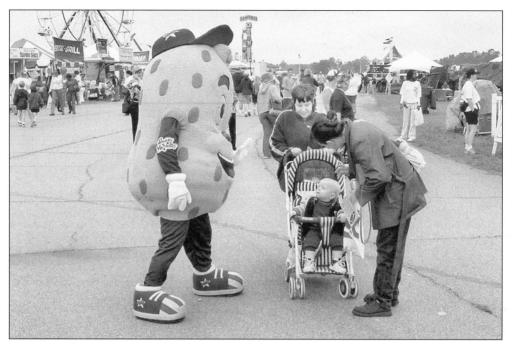

YOU NEVER KNOW WHO YOU'LL MEET. While P-Nutty and Mr. Peanut are common sightings at Peanut Fest, the crowd was treated to an appearance by Buddy McNutty, the spokesnut from the National Peanut Board, a research and promotion board that works on behalf of American peanut farmers, in 2002. (PEH.)

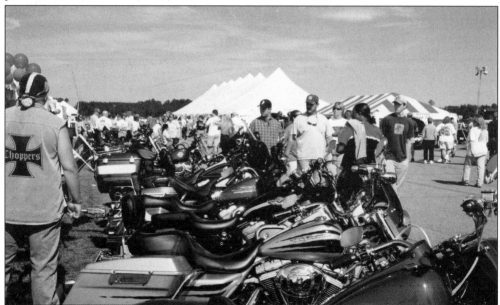

GET YOUR MOTOR RUNNING. Begun as a separate activity in 2002, the Great Dismal Swamp "Swamp Roar" became one of the festival's official activities in 2003. Motorcycle enthusiasts bike along a leisurely 70-mile route around the nearby Great Dismal Swamp National Wildlife Refuge, raising funds for the Great Dismal Swamp Coalition. More than 350 bikers participated. (SPF.)

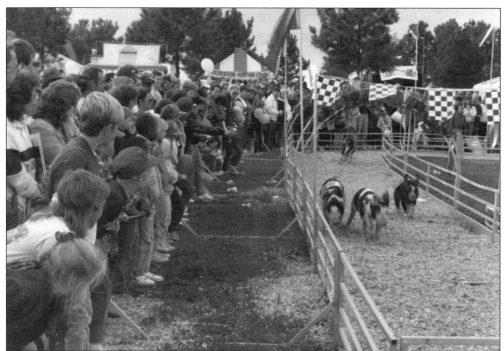

AHEAD BY A SNOUT. What festival would be complete without some crazy animal antics? In this 1987 photograph, racing pigs are seen running around a ring for their prize while crowds cheer them on. Other Peanut Fest animal connections have included a mule that high-dives into a pool of water, elephant rides, and a petting zoo. (SPF.)

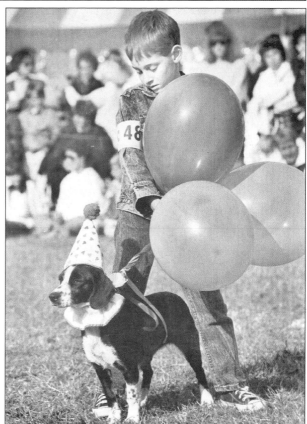

DOGS LOVE PEANUT BUTTER. In this 1988 photograph, six-year-old Chris Miller holds onto his smartly dressed dog Lady during the Peanut Festival Dog Show. Maybe she smells fresh-roasted peanuts. The festival tries to appeal to a wide range of guests by offering such varied events as the dog show, peanut butter sculpture contest, demolition derby, carnival rides, and a yo-yo contest. (SPF.)

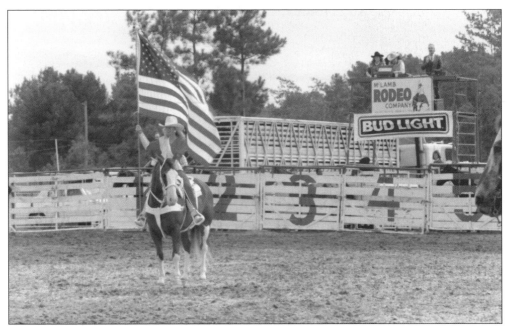

RIDE 'EM COWBOY. A wide assortment of events and activities take place at Peanut Fest, such as this 1990 rodeo, all selected to give broad appeal to the diversity of fest-goers. Other events have included a demolition derby, an air show, a monster-truck demonstration, mud wrestling, and a stock-car race. (SPF.)

PEANUT FUN RUN. A popular event of fests past was a 5K run through downtown Suffolk, held in conjunction with the Peanut Fest. A myriad of sporting events have been held over the years, showing that the festival is more than just peanuts, including a rodeo and golf, volleyball, and basketball tournaments. (SPF.)

ALL TOGETHER NOW. Some of the 100-plus runners in the Peanut Fest 5K race make their way down Suffolk streets in this late 1980s photograph. The run was a part of fest events for about 10 years and drew hundreds of participants. It was usually held the week of the festival. (SPF.)

HOPPIN' HAPPY. There is always a variety of community-based events at Peanut Festival, such as the sack race that the pair of "nuts" in this photo are participating in. Other events have included basketball and volleyball games, all fun and refreshing diversions. There is also a number of children's activities in the Gooberland area, set up especially for kids. (SPF.)

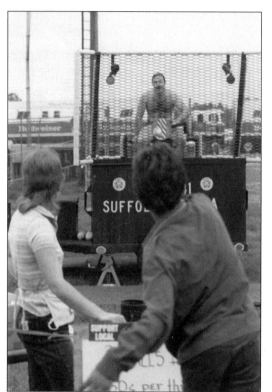

DUNK AND GO NUTS. It's sink-or-swim time for the police officer in the dunking booth shown in this late 1980s photograph. The Peanut Fest provides many local community groups the opportunity to raise money for their cause, such as the funds being raised for the Suffolk Fraternal Order of Police by hosting a dunking booth, the Suffolk Ruritan Club's Shrimp Feast, and more. (SPF.)

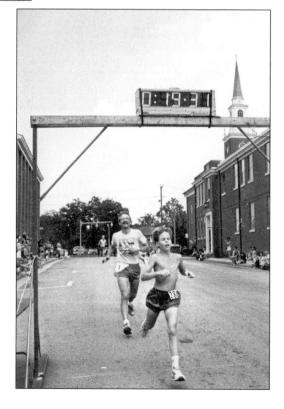

HE MADE IT. For more than a decade starting in the early 1980s, the 5K run was part of the myriad of activities associated with Harvest Fest and Peanut Fest. The race would usually start and end at the municipal center and wind its way through downtown Suffolk. In this 1989 photograph a young racer crosses the finish line. (SPF.)

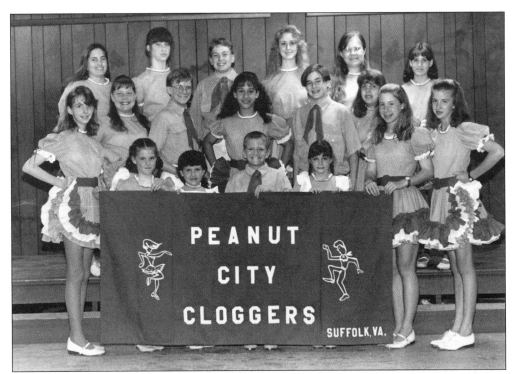

TIME TO GET CLOGGING. The Suffolk Peanut Festival has always been a venue for a wide range of entertainment, from high-school bands and school choruses to nationally known recording artists. A popular form of entertainment is clogging, and hometown Peanut City Cloggers, seen in this early 1990s photograph, is always a favorite. (SPF.)

TOOTING THEIR OWN HORNS. Although Peanut Fest draws some 200,000 visitors each year from all across the region and even from out of state, it is still very much a Suffolk event. It seems that almost everyone in town is involved in one way or the other, such as the band from Nansemond River High School, shown in this photograph. Schools provide entertainment at the parade and throughout the fest. (SPF.)

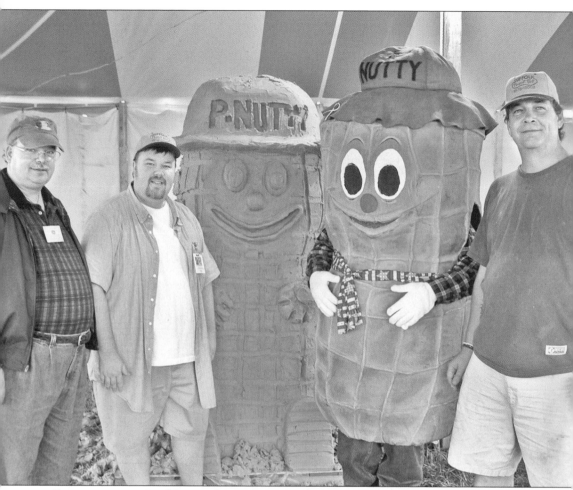

SOMETHING TO GO NUTTY OVER. P-Nutty, the mascot of Peanut Fest, stands beside his likeness carved out of a 2,500-pound block of peanut butter. From left to right are Jim Pond, president of Producers Peanuts, the company that manufactured and donated the peanut butter used in the sculpture; Patrick Evans-Hylton, a festival board member who developed the idea and coordinated the carving; peanut-butter P-Nutty and the real P-Nutty; and Mark Hall, a Virginia Beach artist. P-Nutty was "born" in 1987, crafted after a design by Suffolkian Barbara West. The character, sporting a red straw hat and matching handkerchief around his neck, can be found walking around the fest site greeting guests. A volunteer member of the goodwill ambassador Goober Gang usually wears the costume, which can get pretty hot even in early October. P-Nutty's relationship to Mr. Peanut has yet to be determined, but they appear to be nuts that have fallen off the same family tree. (PEH.)

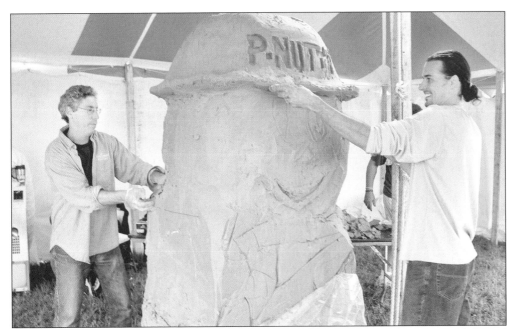

A LITTLE OFF THE TOP. Steve Marsey, a chef and food writer for *Portfolio* magazine, left, and Chad Martin, chef and owner of Norfolk's Blue Hippo Restaurant, help carve a 2,500-pound block of peanut butter into P-Nutty during the 2003 Peanut Fest. Marsey, Martin, and team members Mark Hall and Patrick Evans-Hylton carved the behemoth in a bid to get into the *Guinness Book of World Records*. (PEH.)

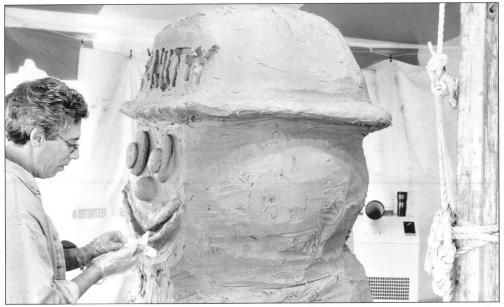

A VERY MESSY JOB. Chef and food writer Steve Marsey dons plastic gloves in preparation for sculpting a one-ton-plus block of peanut butter into the likeness of the Peanut Fest mascot P-Nutty in 2003. Portable air conditioners blew on the block to help keep it cool and prevent it from melting. Sculptures used metal rulers and tools to prevent body heat from their hands turning the art to mush. (PEH.)

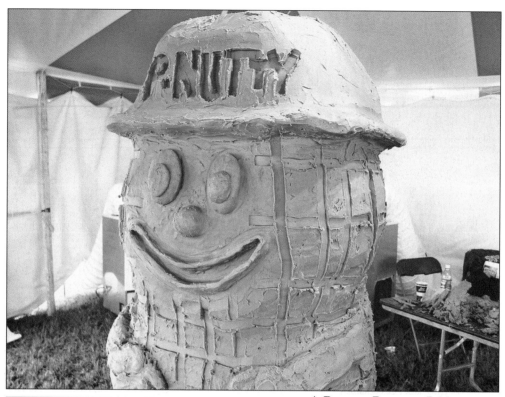

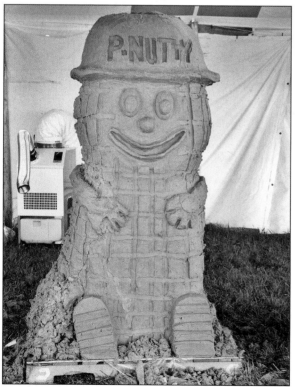

A PEANUT-BUTTERY P-NUTTY. After being crafted by a group of chefs and artists, this 7-foot, 2,500-pound solid slab of peanut butter was turned into a likeness of P-Nutty, the mascot for Peanut Fest. The carving, which was inspired by the peanut-butter sculpture contest where a one-foot-square block of peanut butter is used, was done in 2003. Sanitary methods were used to ensure the peanut butter remained an edible product, one of the requirements for being considered in the *Guinness Book of World Records*. Thousands of fest-goers piled in to see the work of art. A huge block of peanut butter was crafted and donated by Suffolk's Producers Peanuts for the carving. (PEH.)

GRILL ME SOMETHING GOOD. It's not just peanuts at Peanut Fest. A center-court area has a wide assortment of festival foods, from grilled sausages to hamburgers, Thai food, pizza, giant turkey drumsticks, french fries, kettle corn, deep-fried Twinkies, and more. But if you want peanuts, there are plenty of those too—raw, roasted, and baked into pies, cakes and, cookies. (SPF.)

A TIME TO INDULGE. Favorite festival foods like funnel cakes, kettle corn, popcorn, and candy apples abound at Peanut Fest. There is also food to take home: vendors selling tins of gourmet peanuts, containers of peanut brittle, and boxes of peanut butter cookies give fest-goers something to much after they leave. (SPF.)

THE GOOBER GOURMET. Susan Pendleton of Suffolk shows off her winning peanut-butter truffles, an entry in the first Peanut Fest Gourmet Goober Cook-off held in 2002. Cash prizes are given for the top selections in a number of categories. All entrees must use peanuts or peanut butter as a primary ingredient. Local chefs and culinary experts judge the contest. (PEH.)

PEANUTTY TREATS. These contestants were winners in the first Peanut Fest Gourmet Goober Cook-off held in 2002. From left to right are Wilma Hylton of Chesapeake, winner in appetizers/sides for her broccoli salad; Kadi English of Suffolk, winner in pies/cakes for her peanutty peanut-butter brownies; Susan Pendleton of Suffolk, winner in cookies/confections for peanut-butter truffles; and Betty Jo English of Suffolk, winner in entrée for peanut-crusted pork with popovers and peanut gravy. (PEH.)

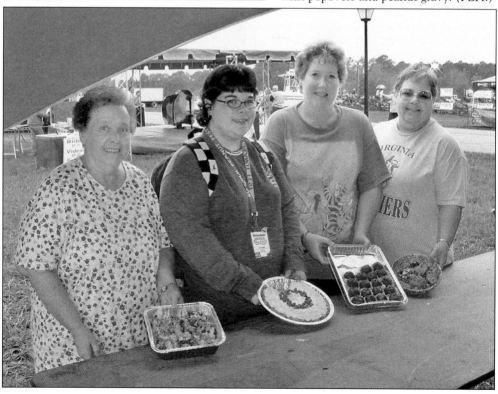

SOMETHING NUTTY IS GOING ON. Dominated by a 32-foot-tall peanut, this display from the National Peanut Board at the 2002 festival is just one of the many exhibitions found at Peanut Fest. Area hospitals are present to offer health screenings and advice, the Virginia Marine Science Museum often comes with a "touch tank" of Chesapeake Bay sea life, branches of the military have equipment on display, and more. (PEH.)

WHAT WOULD PEANUT FEST BE WITHOUT PEANUTS? This late 1970s photograph shows the reason behind the celebration that began as Harvest Fest and continues as Peanut Fest: peanuts. Some 400,000 pounds of peanuts are given away during the festival, many by members of the Goober Gang and others as samples from commercial enterprises. (SPF.)

SKYROCKETS IN FLIGHT. A full day at the Suffolk Peanut Festival is capped off with a fireworks display. The festival offers a myriad of activities, including carnival rides and games of chance, museum exhibits, children's activities, senior days, festival food, an arts and crafts tent, a demolition derby, and several stages of continuous entertainment. There is also a Goober Gourmet Cook-off that gives cash prizes to entries using peanuts or peanut butter, a peanut-butter sculpting contest, and a peanut-butter sculpture demonstration. Peanut Fest has been featured in many magazines including *Southern Living*; *The Southern Farmers Almanac*; *Best Festivals—Mid Atlantic*; *Saveurs*, a French cooking magazine; and *Virginia Business*. The festival kicks off in early October with The Peanut Fest Queens Luncheon and Fashion Show and continues with the parade and Suffolk Ruritan Shrimp Feast before the Peanut Fest's main four-day event. (SPF.)

PEANUTS PREPARED ANY WAY YOU LIKE THEM. Peanut Fest is a chance to fulfill peanut-snacking fantasies, whether enjoyed raw, roasted, candied, or in pies, tarts, or cookies. Many local groups, like the Whaleyville Ruritan Club and the Jackson Circle Women's Fellowship of Bethlehem Christian Church, use Peanut Fest as a fund-raiser, selling homemade peanut pies, salted-in-shell peanuts, roasted peanuts, Cajun-style peanuts, and more. (SPF.)

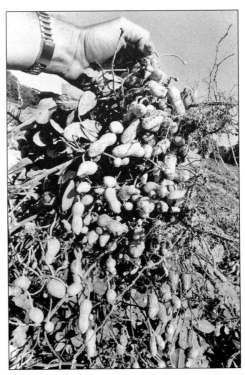

IN A NUTSHELL, FUN! A new logo for the Suffolk Peanut Festival made its debut in 2003, the first image change since the current Peanut Fest began. The logo is emblazoned on tee shirts, jackets, and signs that go up along city streets all over Suffolk in the weeks leading up to the fete. (Courtesy of Suffolk Department of Tourism.)

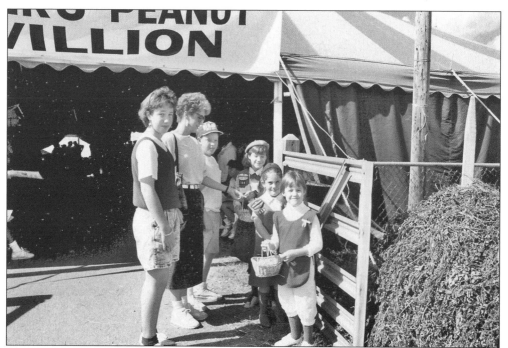

WELCOME TO PEANUT FEST. Visitors are greeted at the entrance tents of Peanut Fest by civic groups and members of the Goober Gang, handing out festival programs and, of course, plenty of samples of peanuts. On display at the right of this 1990s photo is a traditional shock of peanuts. (SPF.)

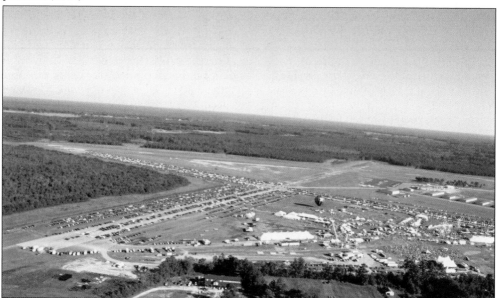

THE FESTIVAL SITE FROM THE AIR. The first celebrations of the peanut in the 1940s, the Harvest Festival of the 1970s and 1980s, and the Peanut Festival of the early 1980s were all celebrated at Peanut Park in downtown Suffolk. After a while the crowds the fete drew couldn't be contained, and in 1981 the festival moved to its current site at the Suffolk Municipal Airport, just south of downtown. (SPF.)

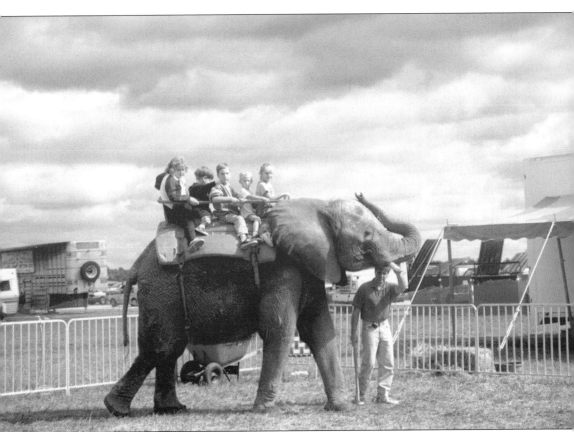

CLOSE, BUT NO JUMBO. Children enjoy a ride on the back of this elephant at a Peanut Festival in the early 1990s. Since P.T. Barnum introduced Jumbo the Elephant at his circus in 1882, the elephant and the peanut—a popular snack food at his shows—have been linked. In the early Peanut Festival celebrations, fete organizers capitalized on this fact by having elephants on loan from the circus feast on a ton of peanuts dumped in the middle of downtown Suffolk. Elephants were also a common theme in advertising for peanuts. Suffolk Peanut Company used the elephant as a theme in their festival floats. The ties between goliath and goober are seen here. There is no word that this elephant worked for peanuts. (SPF.)

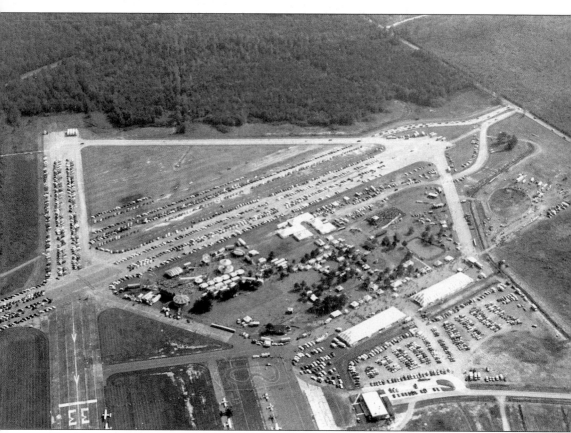

THE FESTIVAL GROUNDS. Since 1981, the Suffolk Peanut Festival has been held at the Suffolk Municipal Airport. Near the bottom of this photo the entertainment stages can clearly been seen. The Peanut Fest has long been known for its entertainment. There is live entertainment, such as strolling minstrels, clowns, and other performers throughout the festival and on the midway, and local musical acts and performances by clogging and karate groups take place on the Harvest Stage and Peanut Stage. There is a main stage where national recording artists perform. One of the first performers was Virginia Beach native Juice Newton. Over the years headline entertainment has performed at Peanut Fest as well, including Eddie Rabbitt, the Mamas and the Papas, Billy Ray Cyrus, 10,000 Maniacs, Patty Loveless, the Dixie Chicks, Jefferson Airplane, Blue Oyster Cult, and Aaron Tippin. The only cost is a parking fee. (SPF.)

EVERYTHING'S COMING UP PEANUTS. Someone could figure out this was Peanut Fest without being told—goobers are everywhere. In this picture from the 2002 festival a water-spouting peanut-shaped fountain is next to an American flag collage of painted red, white, and blue peanuts. Suffolk is proud to be "a little nuts" sometimes. (PEH.)

WHAT TO DO WITH ALL THOSE PEANUTS. Chef Duane Nutter (his real name!) of the National Peanut Board demonstrates the many culinary uses of peanuts at the 2002 Peanut Festival. During his demo, chef Nutter espoused the many nutritional benefits of the legume. In addition to eating out-of-hand and in an assortment of sweets, peanuts are good in many savory dishes, like peanut soup and chicken satay in peanut sauce. (PEH.)

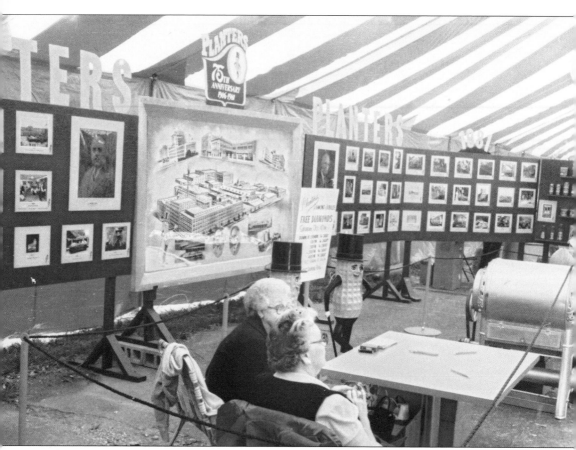

An Homage to Planters. Suffolk was well on its way to becoming the premier peanut market when Planters Peanuts came to town in 1913, but their name, and that of Mr. Peanut, has almost become synonymous with goobers. This display at a 1990s Peanut Fest pays tribute to Planters. Many peanut and other businesses, local schools, and civic groups have exhibits at the festival. (SPF.)

Six

THE PEANUT
LEGACY TODAY

The largest reminder of Suffolk's peanut past comes each October, when 200,000 gather at Peanut Fest. The four-day celebration features entertainment, festival foods, and activities centered around the peanut. Two museums honor the peanut: an exhibit in Suffolk's Riddick's Folly Museum has artifacts and memorabilia of the city's peanut legacy; in Waverly, the First Peanut Museum in the USA also offers displays and exhibitions honoring the goober. The peanut's legacy is apparent at Character Corner, the Obici-Oderzo Fountain, Peanut Park, Obici House, Planters Club, and Obici Hospital. A drive through the factory district is accented by an army of cast-iron Mr. Peanuts sitting on the fence outside the Planters factory. The tastiest hallmark of the peanut legacy is the peanut itself, found in a variety of styles at retailers around town, like the Planters Peanut Center.

PEANUT PARK. Visitors to Suffolk today notice all around them a nod to the city's peanut past and present, including this half-acre public park, outfitted with a softball field, just south of downtown. Peanut Park was the site Harvest Fest and Peanut Fest until 1981. Planters Peanuts deeded the land to the city in May 1920. (PEH.)

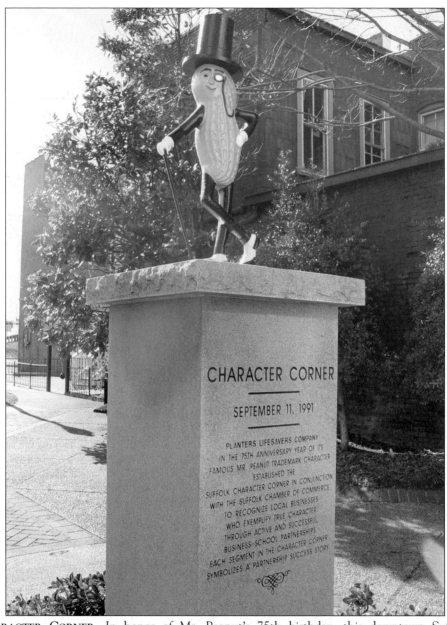

CHARACTER CORNER. In honor of Mr. Peanut's 75th birthday, this downtown Suffolk mini-park was established in 1991. A three-foot statue of Mr. Peanut was placed atop of six-foot granite pedestal at the corner of West Washington and Main Streets. Information about Planters and Mr. Peanut's legacy in Suffolk is engraved in the granite. Park benches and shade trees provide a nice small respite. City and Planters officials dedicated the statue. In 1993 Mr. Peanut was taken down for a few weeks to receive a new coat of paint. Character Corner isn't the only Planters tribute downtown. Just north of Mr. Peanut, near the Godwin Courts Building, is another mini-park. In the center is a small elegant fountain that looks like it belongs in an Italian piazza. The Obici-Oderzo Fountain was built in 1993 to honor Amedeo Obici, founder of Planters Peanuts, and to recognize the relationship with his hometown of Oderzo, Italy, which is a sister city of Suffolk. (PEH.)

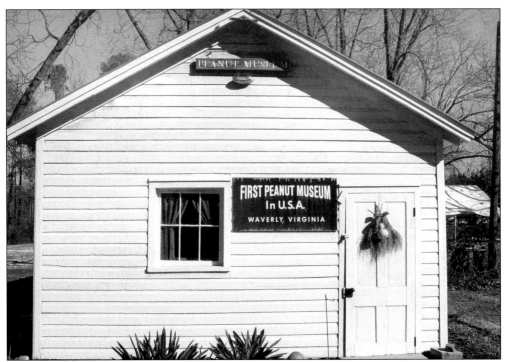

THE FIRST PEANUT MUSEUM IN THE USA. This small white clapboard building, which opened in 1990, pays tribute to the peanut. Located in Waverly, Virginia, the museum is just a few miles north of where tradition says the first commercial crop of peanuts in the United States was planted by Matthew Harris in 1842. The small structure, a former storage house, sits behind the Miles B. Carpenter Museum, which honors one of the state's most famous folk artists. The building is full of peanut memorabilia and artifacts. Old photographs, showing peanut cultivation and production, are on the wall. In the museum and on the museum grounds are farm and production related equipment, like a peanut roaster, peanut sheller, peanut grader, peanut planting machine, peanut cultivator, and peanut digger plow, some dating back to 1880. (PEH.)

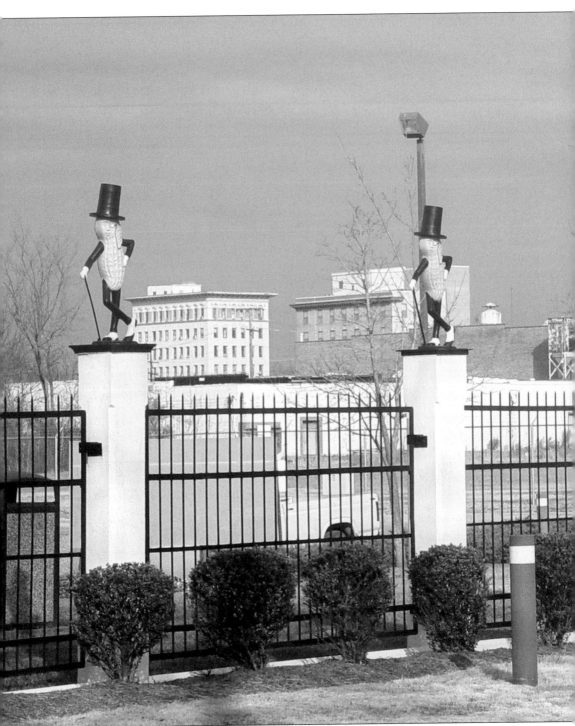

ALL THE MR. PEANUTS, LINED UP IN A ROW. Like they did at the original Planters Peanut factory, these Mr. Peanut fence sitters stand guard at the new Planters facility, which opened in Suffolk in 1994. In the background downtown Suffolk—just a few blocks away—can be seen. The open field is where the old plant stood, just to the north of the new one. The eight-story

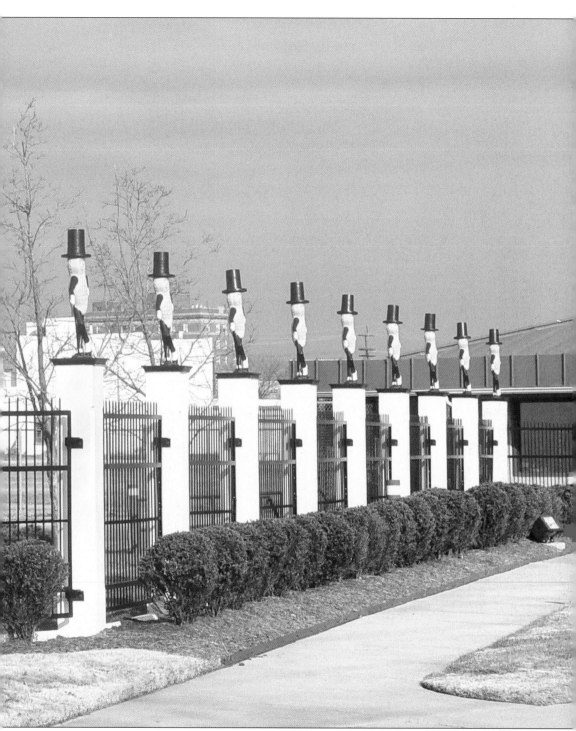

Johnson Avenue plant, expanded three times, stood as an icon of Suffolk's history for 82 years. It was leveled in seven seconds by a ton of dynamite on July 8, 1995. The blast left about 2,800 truckloads of rubble that took two months to clear. Folks came from miles around to see the blast and cheered as the building heaved and collapsed onto itself. (PEH.)

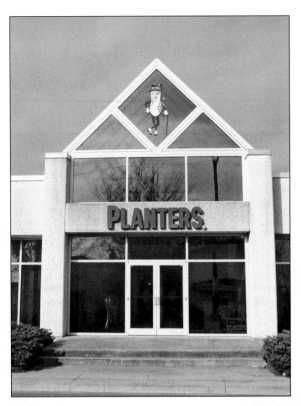

PLANTERS PEANUT'S OPERATION IN SUFFOLK TODAY. This new nut-processing plant was opened in 1994 near the site of the Johnson Avenue plant that Amedeo Obici opened in 1913. This $35 million, 220,000-square-foot facility is located on Culloden Street in the factory district. A "modern" Mr. Peanut at the entrance augments the "traditional" Mr. Peanut fence-sitters that surround the facility. (PEH.)

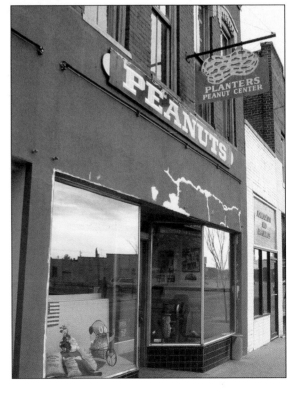

HOT ROASTED PEANUTS. Since 1967 the Planters Peanut Center has been serving up hot roasted peanuts and a myriad of peanut products to Suffolkians and now, through the advent of the Internet, to folks around the world. Located in a simple, centuries-old brick building in downtown, the marquee simply reads, "Peanuts," a deliciously deceptive descriptor. (PEH.)

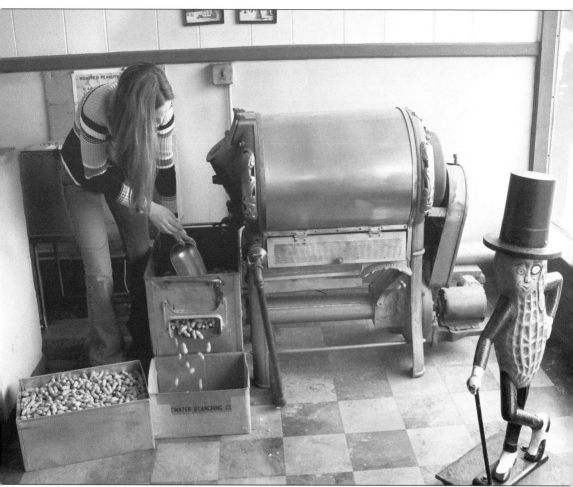

INSIDE THE PLANTERS PEANUT CENTER. This quaint country store first opened in 1967, the idea of a former Suffolk High School principal who thought it would be a good thing to have a place for teenagers to get some work experience. A visit to the Planters Peanut Center is a delicious trip to yesteryear. Old photos, posters, and memorabilia dot the walls. The glass display cases are filled with peanuts double-dipped in chocolate, roasted and salted peanuts, and more. Orders are scooped up into paper bags. Tins of nuts line shelves. Burlap bags filled with nuts hang on the wall. In the corner an early 20th-century, gas-fired roaster hisses and roars, turning out a hundred pounds of roasted nuts a day, as shown in this photograph. Clerks still calculate orders by ciphering out on scrap paper the totals and tax. For folks who don't live in town or aren't visiting Suffolk, the goodness can be ordered via the Internet. (PEH.)

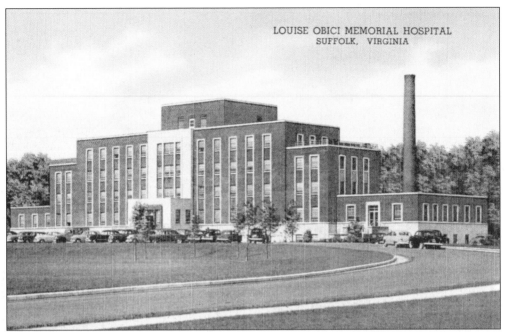

LOUISE OBICI MEMORIAL HOSPITAL
SUFFOLK, VIRGINIA

THE LOUISE OBICI MEMORIAL HOSPITAL. It was the wish of Louise Obici, wife of Planters Peanut founder Amedeo Obici, that a hospital be built to take care of the health needs of folks in the Italian couple's adopted hometown, Suffolk. When she died in 1938 Amedeo established a charitable trust to build the hospital she had wanted. Construction on the original hospital on North Main Street, shown in these vintage postcards, began in the summer of 1949, and the hospital was dedicated on September 16, 1951. In 2002 the hospital moved to new facilities a few miles north. (TO.)

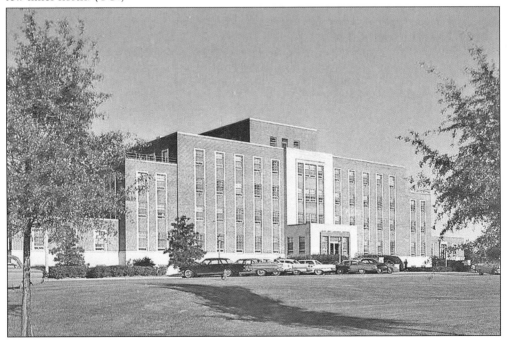

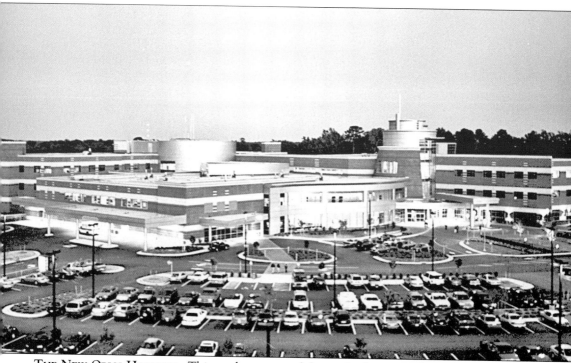

THE NEW OBICI HOSPITAL. This modern, state-of-the-art facility opened in 2002 a few miles north of the original Obici Hospital, which needed upgrading after 50 years. The 138-bed facility serves residents of Suffolk and Western Tidewater. When the hospital moved, the Obicis moved, too. The couple was originally laid to rest in the I.O. Hill family mausoleum in Cedar Hill Cemetery, but their remains were moved in 1949 to a crypt in the lobby of the original hospital, since it was Obici's wish that they be laid to rest within the confines of the hospital that memorializes his wife. Louise died in 1938; Amedeo died in 1947. When the new facility opened, the pair again moved, this time to tombs overlooking a memorial garden. Portraits of Amedeo and Louise, along with other items relating to the Obici family and their involvement in the Suffolk community, can be seen in the Heritage Hallway, a pictorial display of the hospital's history located on the garden level of the new hospital. (Courtesy of Obici Hospital.)

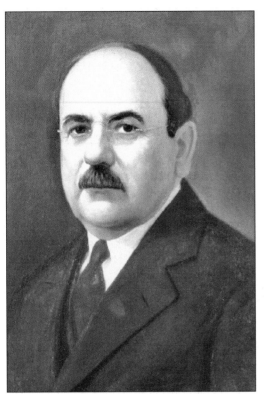

A PORTRAIT OF AMEDEO OBICI. This portrait of Planters Peanut founder Amedeo Obici, painted by John D. Slavin, hangs in the Heritage Hallway at Obici Hospital. A similar portrait of Louise Obici, also by Slavin, is displayed, along with a wide assortment of artwork once owned by the Obicis. Slavin was a well-known mid-20th-century portrait artist, having done paintings of President Harry S Truman, actor John Barrymore, and more. (Courtesy of Obici Hospital.)

JUMBO THE ELEPHANT. One of the advertising pieces on display in the Riddick's Folly "Celebrating King Peanut" exhibit is a statue of an elephant, used to promote shelled peanuts, as seen in the right of this photograph. Also in the picture are wall displays of peanut packages, like jars and cans, and premium giveaways, like Mr. Peanut dolls and calendars. (PEH.)

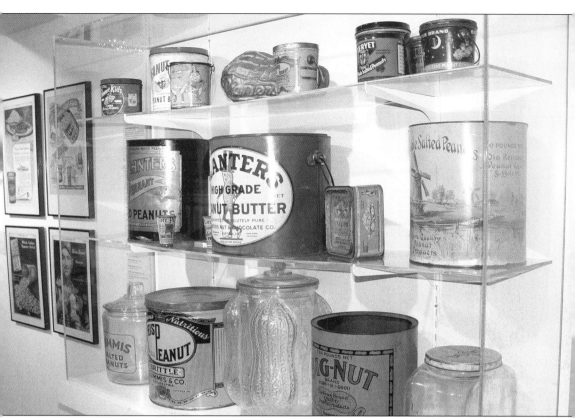

"CELEBRATING KING PEANUT: A SALUTE TO SUFFOLK'S PEANUT INDUSTRY." When this exhibit opened at Riddick's Folly Museum in 1991, it was supposed to have a limited engagement through 1999, but the popularity of the little museum and the homage that it pays to Suffolk's peanut legacy has kept it operating. Locals and visitors alike visit the two-room display, located in the English basement of the 1837 house museum. There is a mix of photographs and memorabilia, like advertisements from mid-20th-century publications and premium prizes and giveaways. There is also an assortment of antique apparatus, such as a peanut basket, old roaster, farm equipment, and burlap-bag stencils. Also on display is an assortment of jars, tins, cups, and cans, like those pictured in the photograph. Some names are very familiar, like Planters, while others are just a fading memory, like Krispeanut, Old Reliable, and Old Dominion. The peanut exhibit is open during Riddick's Folly's regular hours and is included in the house tour. (PEH.)

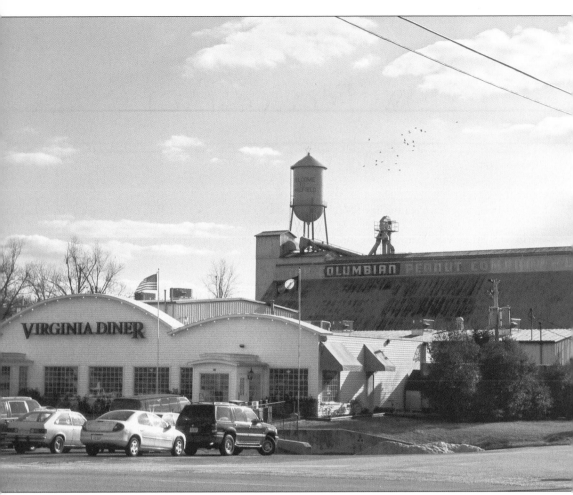

THE VIRGINIA DINER. This diner has been a Virginia tradition for a quarter-century. The eatery started in 1929 when Mrs. D'Earcy Davis began serving hot biscuits and vegetable soup in a refurbished Sussex, Surry, and Southampton Railroad car. The diner began to serve customers peanuts fresh from local fields and prepared in its kitchen instead of after-dinner mints, giving travelers a taste of real Virginia peanuts. It is a custom that is still observed. Although the old railroad car is gone, the diner operates in an open and airy building, filled with red-and-white clothed tables and bentwood chairs. An antique peanut vendor roaster and buckets of free peanuts for munching greets guests at the front door. Lunch and dinner menus include Southern fried chicken, country ham, barbecue, and other traditional fare. A must-try dessert is the peanut pie, gourmet peanuts in a gooey filling in a flaky crust. Tins of gourmet goobers can be purchased to take home. The Virginia Diner is shown in this photo in front of the old Columbian Peanut Company processing plant. (PEH.)

How To Contact

Character Corner
Mini-park, complete with a statue of Mr. Peanut, established in 1991 in honor of the nut's 75th birthday.
At the corner of West Washington and North Main Streets in downtown Suffolk.

Early Peanut Crop Sign
A roadside marker honors where the first commercial crop of peanuts was planted in the U.S.
On the east side of Route 460, about a mile south of Waverly, Virginia

First Peanut Museum in the USA
This gallery chronicles the growth of the peanut as a cash crop.
201 Hunter Street
Waverly, VA 23890
804-834-3327

Murfreesboro Historical Association.
Murfreesboro is the home of Jesse T. Benthall, who helped revolutionize the peanut industry with mechanization. The association has a collection of related antique farm equipment.
116 East Main Street
Murfreesboro, NC 27855
252-398-5922

The Obici House
The home of Planters Peanut founder Amedeo Obici and his wife, Louise, is owned by the City of Suffolk and is on the grounds of Sleepy Hole Golf Course. It is used for private functions.
4700 Sleepy Hole Road
Suffolk, VA 23435
757-538-4100

Obici Memorial Hospital, Heritage Hallway
Items relating to the Obici family and their involvement in the Suffolk community can be seen in the Hallway, located on the Garden Level of the hospital.
2800 Godwin Boulevard
Suffolk, VA 23434
757-934-4400
www.obici.com

Obici-Oderzo Fountain
This small, elegant fountain honors Planters Peanut founder Amedeo Obici and his hometown of Oderzo, Italy, sister city of Suffolk.
Off North Main Street, near the Godwin Court Building in downtown Suffolk.

Peanut Park
The original site of Peanut Fest, now a city park.
Off Carolina Road, two blocks south of downtown Suffolk.

Planters Club
The clubhouse was built by Planters as a social retreat for employees and business associates.
Owned by the city of Suffolk, it is available to rent for parties and other functions.
4600 Planters Club Road
Suffolk, VA 23435
757-538-9518

Planters Peanut Company, Mr. Peanut Fence-Sitters
This collection of three-foot-tall cast-iron Mr. Peanuts rings the outside of the Planters Peanut
plant. There are no factory tours.
245 Culloden Street
Suffolk, VA 23434

Riddick's Folly Museum, Peanut Museum
This 1837 Greek-revival house museum honors the peanut in a permanent display in the
basement of the structure, which includes many interesting artifacts.
510 North Main Street
Suffolk, VA 23434
757-934-1390
http://groups.hamptonroads.com/riddicksfolly

PEANUT PRODUCTS

Peanut Patch
An assortment of peanuts and other gourmet goods sold in a retail store and by mail order.
27478 Southampton Parkway
Courtland, VA 23837
800-544-0896
www.peanutpatch.com

Plantation Peanuts
This shop sells a variety of peanut products in a retail store and by mail order. In front of the
store there is antique peanut farm equipment on display.
On the east side of Route 460 in Wakefield.
800-233-8788
www.plantationpeanuts.com

Planters Peanut Center
A quaint general store with a large assortment of peanut products, including fresh roasted
peanuts from their own vintage roaster. Purchase at the store or by mail order.
308 West Washington Street
Suffolk, VA 23434
757-539-4411
www.suffolkpeanuts.com

Virginia Department of Agriculture and Consumer Services
More information about peanut retailers can be found on the state's website.
www.vdacs.state.va.us

Virginia Diner
Breakfast, lunch, and dinner and an array of peanut products at the eatery and by mail order. On the west side of Route 460 in Wakefield.
888-823-4637
www.vadiner.com

MISCELLANEOUS

Peanut Fest/Suffolk Festivals, Inc.
For four days each October, Suffolk comes alive with the Peanut Fest. Entertainment, festival food (including lots of peanuts), carnival rides, games-of-chance, and more pay homage to the city's favorite cash crop. The event is held at the Suffolk Municipal Airport.
757-539-6751
www.suffolkfest.org

National Peanut Board
This research and marketing board provides recipes and pertinent peanut information.
www.nationalpeanutboard.org

Peanut Pals
Founded in 1978, this group has worldwide members who collect Planters memorabilia.
www.peanutpals.org

Suffolk Department of Tourism
The department operates a visitor center and provides information about the city.
321 N. Main Street
Suffolk, VA 23439
866-733-7835
www.suffolk-fun.com

Virginia-North Carolina Peanut Promotions
A good resource for culinary, historical, and nutritional information about peanuts.
252-459-9977
www.aboutpeanuts.com

ABOUT THE AUTHOR. Patrick Evans-Hylton considers himself a peanut nut after moving to Suffolk in the early 1990s and delving into the rich history of the town and its peanut legacy. He has served on the board for the Suffolk Museum, Riddick's Folly Museum, the historical society, and the Suffolk Peanut Festival. He has written for several area publications, including the *Suffolk News-Herald*. He is an editor at *Hampton Roads Magazine*, a regional city and lifestyle magazine.

BIBLIOGRAPHY

2002 Suffolk Peanut Festival Program. Suffolk, Virginia: Suffolk News-Herald, 2002.

Booker, John Edward, ed. "Illustrated Industrial Edition." *The Suffolk Herald*, 1902.

"Combination of Circus and Hallowe'en Atmosphere to Prevail at the Peanut Exposition." *The Peanut Journal and Nut World.* October 1941.

"Crowds Expected to Visit Suffolk." *Virginian-Pilot.* 29 January 1941.

Hobbs, Kermit and William A. Paquette. *Suffolk: A Pictorial History.* Norfolk, Virginia: The Donning Company, 1987.

Johnson, F. Roy. *The Peanut Story.* Murfreesboro, North Carolina: The Murfreesboro Historical Association, Inc., 2003.

"Mammoth Parade to Climax Peanut Festival in Virginia." 25 January 1925.

Second Annual National Peanut Exposition Program. Suffolk, Virginia: Suffolk News-Herald, 1941.

Suffolk-Nansemond Festival. *1608-1958 Program.* Suffolk, Virginia: City of Suffolk, 1958.

"Suffolk Resembles Carnival as Peanut Festival Opens." *Richmond Times-Dispatch.* 29 January 1941.